G000165128

"A fascinating and deeply r
presentation of the underpi
masterwork rings true to me
tor. His grasp of the organizational arc of *Messiah* as he lays
out connections between its disparate internal components
shows that he can view it all with not only a musical eye, but
a spiritual one as well. I recommend this to anyone seek-
ing a fresh and deeper understanding of Handel's timeless
magnum opus."

 —GARY FRY, Emmy-winning composer

"*Handel's Messiah* is a treasure trove of information for any-
one interested in researching, performing, or just listening
to this magnificent oratorio. This book connects all the dots
as to how *Messiah* is put together with regards to the text
and the music. I have had the privilege of conducting *Mes-
siah* several times in my career, and I sure could have used
this guide in my own preparation!"

 —MICHAEL DUFF, musical director

"As a lover of Handel's *Messiah*, I have always been intrigued
by the wide appeal of a work that is so overtly Christian.
Athnos' book helped me to understand how Handel de-
ployed musical forms, often subversively, to engage the
human heart (or to use the Baroque term, our 'affects') and
even bypass our cognitive 'defenses.' More importantly,
Athnos' book has helped me better *experience* something I
already enjoyed. It can do the same for you."

 —MARSHALL BROWN, senior pastor,
 Grace Presbyterian Church of the North Shore

"How is it that *Messiah*, which took Handel only about three
weeks to compose, continues to captivate audiences nearly
three centuries on? Athnos' book gives us an intriguing

basis on which we might begin to answer that question, showing that there is a lot more going on here than inspiring words and pretty notes. I highly recommend this book to anyone, performer or listener, who wishes to enhance their understanding of Handel's spiritual intent."

—JIM VOGLER, partner, Barack Ferrazzano

HANDEL'S *MESSIAH*

CASCADE COMPANIONS

The Christian theological tradition provides an embarrassment of riches: from Scripture to modern scholarship, we are blessed with a vast and complex theological inheritance. And yet this feast of traditional riches is too frequently inaccessible to the general reader.

The Cascade Companions series addresses the challenge by publishing books that combine academic rigor with broad appeal and readability. They aim to introduce nonspecialist readers to that vital storehouse of authors, documents, themes, histories, arguments, and movements that comprise this heritage with brief yet compelling volumes.

HANDEL'S *MESSIAH*

*A New View of Its
Musical and Spiritual Architecture*

STUDY GUIDE FOR
LISTENERS AND PERFORMERS

GREGORY S. ATHNOS

CASCADE *Books* • Eugene, Oregon

HANDEL'S *MESSIAH*
A New View of Its Musical and Spiritual Architecture
Study Guide for Listeners and Performers

Cascade Companions

Cascade Books
An Imprint of Wipf and Stock Publishers
199 W. 8th Ave., Suite 3
Eugene, OR 97401

www.wipfandstock.com

PAPERBACK ISBN: 978-1-6667-3904-6
HARDCOVER ISBN: 978-1-6667-3905-3
EBOOK ISBN: 978-1-6667-3906-0

Cataloguing-in-Publication data:

Names: Athnos, Gregory S., author.

Title: Handel's Messiah : a new view of its musical and spiritual architecture ; study guide for listeners and performers / Gregory S. Athnos.

Description: Eugene, OR : Cascade Books, 2023 | Series: Cascade Companions | Includes bibliographical references.

Identifiers: ISBN 978-1-6667-3904-6 (paperback) | ISBN 978-1-6667-3905-3 (hardcover) | ISBN 978-1-6667-3906-0 (ebook)

Subjects: LCSH: Handel, George Frideric, 1685–1759. Messiah.

Classification: ML3921 .A85 2023 (print) | ML3921 .A85 (ebook)

And from that time to the present, this great work has been
heard in all parts of the kingdom
with increasing reverence and delight;
it has fed the hungry, clothed the naked,
fostered the orphan, and enriched succeeding
managers of the Oratorios
more than any single production in this or any other country.

—CHARLES BURNEY

Handel was the greatest composer that ever lived.
I would uncover my head, and kneel before his tomb.

—BEETHOVEN

Handel is the Shakespeare of music.

—KING GEORGE III

Handel is not a mere composer in England; he is an institution.
What is more, he is a sacred institution.

—GEORGE BERNARD SHAW

CONTENTS

Contents

INTRODUCTION

HANDEL'S *MESSIAH* IS THE most performed musical composition in history; no one can escape it. Each year thousands of performances involving millions of performers circle the globe. My first performance as conductor took place sixty-three years ago, at age twenty-two, with a small church choir in a Detroit suburb. My last performance, my fourteenth, was at age seventy-two in Chicago, fifty years after my first. I've conducted fourteen *Messiah* performances, four *Singalong Messiahs*, given radio and television interviews, and taught numerous university classes on the masterpiece. It was my privilege to appear as guest conductor with the Chamber Orchestra of Pushkin, Russia, and the State Symphony of Estonia in their first performances of *Messiah* since the Bolshevik Revolution.

Through my lifetime of rich experiences with the work I thought I knew it well. But did I? Was there an avenue of understanding I had missed? *Messiah* warranted another look. In graduate school I was introduced to a *musical aesthetic* that was said to have influenced the composers of the Baroque period. Known as *the Doctrine of the Affections*, its premise was that every musical key stimulated a particular emotional/spiritual response in the listener. That was as far as the introduction went. Several years ago I explored the doctrine and was immediately intrigued by the specific

spiritual and emotional intentions embedded in each key. Here are several examples:

D Major—Triumph, Hallelujahs, War Cries, Victory, Rejoicing
Eb Major—Love, Devotion, Intimate Conversation with God
g minor—Discontent, Uneasiness, Worry about a Failed Scheme
A Major—Declarations of Innocent Love, Hope of Seeing One's Beloved Again, Trust in God

I began applying the doctrine to each of the movements and was astounded by what I discovered. When facing a choice between following the accepted theoretical rules of musical composition or using the affect best suited to the scriptural text, Handel almost exclusively chose the affect. In other words, spiritual and emotional connections trumped standard compositional practices. Overlaying the various affects on each movement of Handel's composition reveals the true heart and intent of the composer.

Handel used particular affects in more than one movement, thereby revealing the unification of the texts. The result connects "prophetic declarations" with "prophetic fulfillments"—a thoroughly biblical approach. I use the affects in descriptions of each movement's text; it is the major theme of my manuscript.

His extramusical choices fortify the notion that, above all, he was seeking a spiritual connection; most analyses of *Messiah* concentrate primarily on the musical components.

We begin with questions. Why did Charles Jennens create his *Scripture Collection*? Why did he choose these Scripture verses and not others? What was his purpose? Handel's setting of Jennens' *Scripture Collection* employed a musical architecture, but was there a spiritual architecture as well? If so, was there a symbiotic relationship between the two architectures? Did he use the Doctrine of the Affections?

In examining *Messiah* through the prism of the Doctrine of the Affections we discover Handel's heart for the texts. Sharing that discovery is the motivation behind this study guide: to assist listeners and performers alike to discover what is unfamiliar about this familiar work, to listen and perform with greater understanding and conviction, and to reclaim the profound message at the heart of Jennens' and Handel's magnum opus.

1

THE BAROQUE DOCTRINE OF THE AFFECTIONS

BEFORE DISCUSSING THE HISTORY of *Messiah*, the reasons
for its creation, the people who executed the plan, and
analyzing the work itself, we begin by examining a new
approach to understanding Handel's masterpiece: the Doc-
trine of the Affections.

The Doctrine of the Affections, also called the *Doc-
trine of Affects*, was a theory of musical aesthetics widely
accepted by late Baroque aestheticians and composers. It
embraced the proposition that music is capable of arous-
ing a variety of *specific* emotions within the listener. Music
does indeed arouse emotional responses; the key word here
is *specific*. At the center of the doctrine was the belief that
composers could create a piece of music capable of produc-
ing a *particular* and *specific* involuntary emotional/spiritual
response in their audiences.

Lorenzo Giacomini Tebalducci Malespini (1552–98)
described the ancient theory in his *Orationi e discorsi*

(1597). He defined an affect as a spiritual movement of the mind that attracts or repels due to an imbalance in the "animal spirits and vapors" flowing continually throughout the body. Later musicologists clarified the doctrine by stating that affections are not the same as emotions, though they affirmed that affections are a spiritual movement of the mind.

Each major and minor key used by Baroque composers was thought to prompt a particular spiritual movement of the mind. It was not necessary for the listener to know what key was being employed, or even to know the spiritual movement intended. It was embedded in the power of music itself to elicit the desired response.

This treatise will focus on the Doctrine of the Affections and its application, movement by movement through *Messiah*, for the purpose of discovering the heart of the composer and his spiritual intent. Knowing his intent, both musical and spiritual, will lead to a greater appreciation of his theological commitment to the chosen texts. To be aware of his intended purposes and choices will enhance our already emotional and spiritual encounter with his masterpiece. Our examination will show that Handel purposefully used the Doctrine of the Affections and did so with deep thought.

In summary, my thesis is that the Doctrine of the Affections was used by Handel, movement by movement through *Messiah*, to foster a specific and particular involuntary or subconscious emotional/spiritual response in the listener, a response appropriate to each text.

MESSIAH: KEY CENTERS AND TEXTS

Listed below are the major and minor keys used in *Messiah*.[1] To each is attached the spiritual movement of the mind, or affect it was thought to create. It must be stated, once again, that the listener does not need to know the key or its intended affect. The doctrine was a device for the composer to express how he interpreted the text. Regardless of the listener's awareness of his purpose, the theory held that the intended affect would be achieved. We will examine each chosen affect and its appropriateness to the text. How carefully did Handel approach each text, and how clearly did he understand its spiritual and theological implications?

Handel frequently abandoned traditional compositional practices in *Messiah*. Whenever there was a choice to be made between the normal *theoretical* approach to the music and the affect more appropriate to the text, the composer chose the affect. He sacrificed the *theoretical* for the *spiritual*. Listed below are the keys used in the work and their intended affect. Notice their specificity; they provide the clues to understanding Handel's spiritual commitment to the texts:

1. The findings are taken from Christian Schubart's *Idea zu einer Aesthetik der Tonkunst (1806)*, translated by Rita Steblin in *A History of Key Characteristics in the Eighteenth and Early Nineteenth Centuries* (Studies in Musicology 67, Ann Arbor, MI: UMI Research Press, 1983); also from Marc Antoine Charpentier's *Regles de Composition* (ca. 1682). Other sources include *Encyclopaedia Britannica*; *Journal of Seventeenth-Century Music* (1999) 5.1: *Musica Poetica: Musical-Rhetorical Figures in German Baroque Music*, by Dietrich Bartel (Lincoln: University of Nebraska Press, 1997, as reviewed by George J. Buelow, 22–25); Claude V. Palisca, *Baroque Music*, 3rd ed. (Prentice Hall History of Music Series; Englewood Cliffs, NJ: Prentice Hall).

C Major:	Completely pure. Innocence. Simplicity. Naïveté.
c minor:	Declaration of love, and lament of unhappy love. Languishing. Longing. Sighing.
D Major:	Triumph. Hallelujahs. War cries. Victory. Rejoicing.
d minor:	Melancholy. The spleen and humours brood.
Eb Major:	Love. Devotion. Intimate conversation with God.
E Major:	Noisy shouts of joy. Laughing pleasure. Not yet complete delight.
e minor:	Grief. Mournfulness. Restlessness.
F Major:	Calm (always identified in *Messiah* with sheep and the Shepherd).
f minor:	Deep depression. Funereal lament. Groans of misery. Longing for the grave.
G Major:	Gentle, peaceful emotions of the heart. Satisfied passion. Tender gratitude.
g minor:	Discontent. Uneasiness. Worry about a failed scheme.
A Major:	Declarations of pure love. Hope of seeing one's beloved again. Trust in God.
Bb Major:	Cheerful love. Hope. Aspirations for a better world.
Bb minor:	A creature of the night. Surly. Mocking God and the world.
b minor:	Patience. Calm. Awaiting one's fate. Submission to divine dispensation.

MAKING CONNECTIONS

Stories unfold in linear fashion like a highway, with a departure point and a destination. In studying *Messiah* there is another more challenging and more rewarding way. One

must always look in the rearview mirror. Instead of wondering where you're going, think instead of where you've been. Move forward while looking backward. That's exactly what Handel has done; he accomplishes the linkage with past scriptural texts through his use of affect. If a particular affect is used only once (there are several instances), the text is of singular importance. When several movements share the same affect it is important to look back to the last example and ask what their texts have in common or how the latter text is a fulfillment of, or builds upon, the previous text. In other words, fulfillment of a prophecy is linked through the affect to the prophecy itself.

Musician/performers have the advantage by virtue of having the musical score in hand; listeners are at a disadvantage. In all cases it is important for listeners and performers alike to realize that almost every movement in *Messiah* is a response to what has preceded it. As we work our way through the *oratorio* this approach will dictate how the individual movements are defined.

2

CHARLES JENNENS, DEISM, AND THE ENLIGHTENMENT

Two worldviews dominated Baroque Europe: *Deism* and the *Enlightenment*. Deism emerged during the rise of science and came to exert a powerful influence on the age we call Baroque (1600–1750). Deism stood between what was considered the narrow dogmatism of organized religion and the growing skepticism of the Enlightenment. Deists did not abandon the *idea* of God—they acknowledged his existence—but thought he was no longer concerned with or involved in the affairs of his creation. He had put in place *natural laws* so that the universe, considered a "clockwork" mechanism, could run itself without his intervention. Deists held that human beings could know God only via *reason* and the observation of nature. *Revelation* and the *supernatural* (miracles) were dismissed along with claims that Judeo-Christian Scriptures contained the revealed word of God. Deism was insidiously taking over many religious institutions, adding further fuel to the diminution of faith in God's activities with his creation.

The Enlightenment was the more secular side of the equation, and came to dominate the cultural centers of Europe from Vienna to Paris to Berlin to London. Its purpose was to reform the citadels of society using reason to challenge *tradition* and the dictates of organized religion. Superstition, an epithet attached to the church by Enlightenment thinkers, needed to give way to more intellectual pursuits. It was not a good time for the church.

Onto the stage of history stepped Charles Jennens (1700–1773), an English landowner and patron of the arts who stood opposed to those antireligious movements. He was a devout Christian committed to the orthodoxy of the Christian faith and the Church of England. He believed in the fundamental truths of Christianity and the divine inspiration of its holy texts. He acknowledged Jesus as the One prophesied in the Hebrew Scriptures, through whom God offered redemption. He abhorred Enlightenment and deistic thinking, and sought ways to counteract their influence.

Jennens greatly admired Handel's music. He collected every work his friend wrote and knew them well, to the point that he annotated his copies of Handel's operas, adding corrections and making other suggestions for modification. Handel respected his contributions and encouraged them. Their collaboration grew.

At age thirty-five, he began writing libretti for Handel's oratorios, the first being *Saul* (1735–39), and continued soon after with the libretti for two short *Odes* based on John Milton's poetry. Others would follow. Their success cemented the relationship between the two men.

While working on Milton's odes, Jennens was also beginning to assemble biblical texts for another oratorio he intended to give to Handel. He wrote to a friend, informing him he was preparing a *Scripture Collection* to be given to the composer. This letter may be the first inkling

of his intended libretto for *Messiah*. For two years Handel worked on other projects, including music for the two Milton odes, thus allowing Jennens time to refine his *Messiah* plans. In mid-1741, Jennens again wrote to his friend that he intended to have his *Scripture Collection* set to music by Handel in time for Passion Week the following year. He felt the collection excelled every other subject, and for the first time indicated the subject was *Messiah*.

Why did Jennens want Handel to make his *Scripture Collection* into an oratorio? Why not write his own tract, sermon, or polemic and submit it for publication? If that had been his choice it would more than likely have disappeared in a generation, buried under the proliferation of other religious tracts and the onslaught of the Enlightenment. He knew his good friend Handel was famous not only in London, but throughout all of Europe, extending even across the Atlantic. Years before the American Revolution there were Handel *Singing Societies* in New England. Jennens knew Handel's oratorios would attract large audiences and be performed numerous times. He must have been convinced his *Scripture Collection* set to Handel's music would have the power of persuasion it needed and the vast audience he desired. History would prove he made a wise calculation.

3

GEORGE FRIDERIC HANDEL

HANDEL WAS BORN IN Germany in 1685, the same year as Johann Sebastian Bach. Bach was taught by an older brother and spent most of his life within fifty miles of his birthplace. Handel, on the other hand, was privileged to study in Italy, the center of music during those latter years of the Baroque. Everything new in music originated there. Italy was the birthplace of the orchestra, opera, and oratorio. During the course of his southern sojourn Handel became the undisputed master of the Italian Baroque style.

England was infatuated with all things Italian. London was flooded with Italian singers and Italian composers, to the extent that English composers and performers were nearly shut out of performance halls and concert venues. The English wanted the best of the Italian style and they wanted the best Italian composer. It was Handel, the German! He took up residence in London at the behest of the king and began his Italian-style domination of England's musical culture.

Italian opera was all the rage, and soon Handel made his mark. His fame kept him incredibly busy creating new works throughout the 1720s. In the 1730s, things changed. New rival Italian opera companies emerged. Arguments ensued, and opera houses closed. At the same time, the people were becoming disenchanted with Italian dominance of the arts. A clamoring arose among the people for English music sung in the English language using English singers. Choral singing had always been an English favorite; England had a long reputation for choral song, including a great culture of Renaissance madrigals. The oratorio, because of its emphasis on choral singing, began to replace opera in the hearts of the populace.

Handel became deluged by libretti for oratorios, which are stories set to music without staging or choreography. The form was not new to him. Opera and oratorio engaged the same forces: large orchestra, large chorus, a number of soloists, and a compelling story. He had already written two oratorios: *La Resurrezione* (1708, in Italy) and *Brockes Passion* (1716, in Germany).

The traditional oratorio structure, embraced by Handel, featured stories taken primarily from the Old Testament of the Bible, including the apocryphal books. Who could not be inspired, for example, by such stories as Israel's deliverance from the bondage of Egypt (*Israel in Egypt*, 1739), or other Handel oratorios based upon Israel's heroes such as Esther, Deborah, Samson, Judas Maccabaeus, Joshua, Susanna, or Jeptha? These stories played well in the rise of England's global empire; it gave them a feeling of kinship with God's "chosen people" whose heroes were aided in their struggles by the Almighty. While not all Handel's oratorios take their sources from the Old Testament, it is fair to say his most performed compositions had that connection.

Others, fewer in number, were either mythological or allegorical in nature.

The closing of the opera houses provided a decisive and providential moment for Charles Jennens. Handel was having his difficulties with the new sentiments of the English public and was considering returning to Germany. Jennens hoped his new *Scripture Collection*, in English, would reinvigorate the composer and assist in reviving his popularity. Handel received the *Scripture Collection* but put it aside for a time. He was struggling to convert from Italian opera to English oratorio.

Finally Handel felt the time was right. When he began setting the *Scripture Collection* to music, one hundred pages were drafted in just six days! According to tradition he never left his room during that time; his servant brought his meals to him and often found the composer weeping and his meals uneaten. In slightly more than three weeks the entire work was completed and was ready for its audience.

Which audience? One would think London—where Handel's reputation was stellar, where his operas and oratorios had garnered great reviews—would be the most likely venue. It was not to be. For whatever reason, Handel decided to take *Messiah* to Dublin, Ireland. Was he thinking that Ireland, remaining staunchly in the fold of Catholicism, would be more favorably disposed to a "Christian" work?

Not knowing the musical forces available in Dublin, he arranged the orchestration for a small string orchestra augmented by two trumpets and timpani. Two small church choirs formed the chorus. Handel used female alto and soprano soloists rather than the male *castrati* he had always used in his London opera performances. *Castrato* singers combined both the sweetness of a young boy's voice and the power of an adult male's voice. Their singing range was enormous, encompassing over three octaves, nearly

double the normal vocal capability. Why he chose female soloists in Dublin is unknown. Later, in London, he would once again use *castrati*, even in *Messiah* performances.

Handel's decision to have the first performance in Catholic Dublin must not have sat well with Jennens, whose "anti-Popish" views were well known. He had also hoped for a more noteworthy London audience. Furthermore, Jennens was upset with Handel's hasty setting of his libretto—three weeks—thinking that his friend had given little thought to the endeavor. He wrote once more to his friend that Handel had made a fine entertainment of his *Scripture Collection* but not as good as he had hoped; he felt it unworthy of Handel, but more so of *Messiah*.

Only after wooing the Dublin public with concerts of some of his other compositions did Handel finally mount the first *Messiah* performance in April of 1741. He chose the new Music Hall on Fishamble Street instead of an established theater. The ticket proceeds were given to several Dublin charities, which greatly endeared him to the Dublin press. Knowing there would be a large audience eager to hear the premiere, and wanting to make more room in the hall, he suggested that women leave their hoops at home, and the men their swords!

The performance was sold out and the reviews were stellar. *The Dublin Journal* reported,

> Words are wanting to describe the exquisite delight it afforded to the admiring crowded audience. The Sublime, the Grand, and the Tender, adapted to the most elevated, majestick [*sic*] and moving words, conspired to transport and charm the ravished Heart and Ear.[1]

1. Jane Glover, *Handel in London* (London: Pegasus, 2018), 303.

The first London performance one year after Dublin, in 1742, was set in a public hall. In contrast to the Irish the English did not initially like *Messiah*. The press objected to a sacred performance in a place usually filled with what they termed "low-life actors" mounting scandalous plays. They complained that this oratorio, unlike all his others, had no story. There was no cast of characters. No dialogue. No narrative. The soloists had too little to do (compared with opera) and the chorus too much. They had leveled the same criticism against his oratorio *Israel in Egypt* several years earlier. *Messiah* was even more greatly removed from the typical oratorio, and neither the press nor the audience was ready for it. Handel was devastated by their response, and Jennens, seeing the score for the first time, also was unhappy. The two collaborators had a falling out. Jennens commented that in spite of their relationship he would not subject any more of his sacred works to the abuse of the composer.

It was years before *Messiah* became a tradition in England. When Handel began to have the work performed for charity, as he had done in Dublin, the press softened its attitude. Twenty-five years later (unfortunately, Handel had died a decade earlier) *Messiah* was so popular with the English that they almost rioted while waiting to hear it at Westminster Abbey. People screamed, as they feared being trampled. Others fainted. Some threatened to break down the church doors.

There is no definitive version of *Messiah*. Handel always revised his works to suit his performance forces. The Dublin ensemble was very small and cannot be reconstructed with any certainty. Later editions are marked by various instrumental changes as instruments, some refined and others new, were being added to the Baroque orchestra.

Looking back, one sees clearly that *Messiah* was the turning point in Handel's career. It is also fair to say that without Handel's *Messiah*, Charles Jennens and his *Scripture Collection* would be ciphers in history. By the same token, without Jennens there would be no *Messiah*. Call it a chance collaboration between Jennens and Handel. Call it a revelation. Call it inspired. Whatever your view, it is fair to say that no religious musical composition rivals *Messiah* in its appeal, and no such composition has stated the claims of the Christian faith with such a combination of clarity, power, zeal, and reverence. It deserves to be called the single most inspirational musical combination of faith and art in the history of the world.

4

CHARLES JENNENS' *SCRIPTURE* COLLECTION

JENNENS' SCRIPTURE COLLECTION WAS carefully selected from pages across the entire Bible: Old Testament and New Testament. He had a story to tell, a musical drama unlike any opera or oratorio ever written. In my view, his purpose was intended to encapsulate the entire story of human history, from the fall in the garden of Eden to the final gathering around the throne of heaven. Central to the story were the prophecies of the *incarnation, suffering, death, resurrection*, and *second coming of Messiah*. It had to be compelling in order to state an *apologetic* for the Christian faith struggling under the withering attack of the Enlightenment.

Jennens knew opera well, having written several libretti for Handel. The traditional opera had three acts, and that was the model he chose for this undertaking, calling them *Part the First*, *Part the Second*, and *Part the Third*. His distribution of scriptural texts fits nicely into the three-act model. Carefully analyzing the texts and Jennens'

assignment of their place in the drama, I offer these descriptions as titles for each of the three acts and their subsequent scenes:

Act I (Part the First): The Anticipated Redemption
A Cry in the Wilderness
Messianic Prophecies from the Old Testament Perspective
A Virgin Birth
A Messiah Who Destroys the Enemies of God
A Conquering Hero
A Healer, a Peace-Bringer
Act 2 (Part the Second): Redemption Fulfilled
The Prophecies Are Reinterpreted: Messiah Is Rejected. He Suffers and Dies.
His Resurrection Conquers Sin and Death.
The Gospel Is Preached; the Preachers Are Martyred.
God's Enemies Are Defeated.
His Conquest Is Praised.
Act 3 (Part the Third): The Promise to All Believers (New Testament Hope)
Messiah Has Been Raised.
Believers Rejoice in Their Future.
The Trumpet Sounds; the End of History.
A Gathering Around the Throne of Heaven, Praising the Lamb Who Was Slain.

HOW JENNENS' THREE-ACT OPERA UNFOLDS

Examining Jennens' *Scripture Collection* and his stated intent to unfold the story of "redemption" leads to my subheadings or scenes. They will serve as the template for our examination.

Part the First
The World in Darkness
The Promise

Shaking Up the World
Words of a Virgin Birth
Into the Shepherds' Field
Four Images of a Savior

Part the Second
Redemption Through Suffering
Resurrection to Ascension
The Gospel Is Preached
God's Enemies Defeated
The Believers Sing

Part the Third
Firstfruits
Homage to the Triumphant Savior
Around the Throne of the Lamb

5

ORATORIO MUSICAL
COMPONENTS

FOR THOSE READERS LESS aware of opera and oratorio musical components, a brief introduction is in order.

RECITATIVES

In *Messiah*, as in other Baroque oratorios and operas, soloists frequently sing short movements called *recitatives* (reh-si-tah-TEEVs). The name of the style says what is important: recite the words, which are declaimed almost as if they are spoken. Each syllable is stated in its proper length and with its proper accent or emphasis. Generally the line is sung with one note given to each syllable; nothing must get in the way of the text or obscure it. The result is "musical speech." Words in recitatives set the stage and drive the action. Recitatives are perhaps the least compelling musical structures in an oratorio; *arias* and *choruses* are far more musically rewarding. Nonetheless, recitatives convey the necessary "truth links" of the work, and one must pay

close attention. Without them the fabric of the story lacks cohesion.

Two styles of recitatives are used by Handel: *secco* (dry) *recitatives*, and *accompanied recitatives*. The description *secco* refers to the orchestral writing rather than to the singer, with the instruments playing a severely limited role marked by very little activity beyond simple supporting chords. The orchestra gets out of the way of the singer and the text. In *accompanied recitatives* there is generally more orchestral activity and a bit more melodic activity for the singer, but never so much as to detract from the importance of the text.

ARIAS

As a general rule, recitatives are followed by arias, where music becomes the master element. Fewer words are involved, usually comprising a distillation or synopsis of what was stated in the recitative. These phrases are repeated again and again throughout the aria. Words carry less weight in arias than in recitatives; melodies become the dramatic and aesthetic paintbrush. If you remember the textual story line of the recitative you'll be free to listen to its melodic elaboration in the aria. If, on occasion, a chorus follows a recitative, the same rules governing the aria apply.

CHORUSES

Choruses most often introduce new texts not stated in either recitatives or arias. They play a powerful role in propelling the drama, similar to the role of the *Greek chorus* in ancient theater. In Handel's *Messiah*, twenty-two choruses are included, but only three follow recitatives. The other nineteen carry the importance of their texts without the benefit of

a recitative's declamations; conductors must demonstrate significant concerns for what is being stated.

Choruses strive to achieve balance in the composition. In two choruses, "Since by man came death" and "Worthy is the Lamb that was slain," the texts are so important that Handel set them syllabically. Conversely, in choruses like "He shall purify" and "All we like sheep," while the texts carry emotional weight, the melodic and contrapuntal elements carry the emotional drama. In choruses, the challenge is to pay close attention to the text while at the same time allowing the beauty of their musical settings to resonate aesthetically. In choruses, unlike recitatives and arias, texts and melodic settings are completely equalized.

THE ORCHESTRA

Baroque orchestras were still evolving, having been developed in Italy only decades before Handel was born. The violin makers of Cremona in northern Italy (the Amati, Guarneri, and Stradivari families) created the four instruments that would become the foundation of orchestras: violin, viola, cello, and bass. They replaced literally hundreds of types of stringed instruments that had existed previously. Wind instruments were fewer in number and far less technically developed. The first to appear were recorders (predecessors of the flute), oboes, bassoons, and valve-less trumpets.

Conductors were either harpsichordists or occupied the first violin chair, and led from those positions.

Handel's use of the orchestra in his oratorios was similar to that of other composers. On occasion the ensemble simply accompanied the actions of the singers by playing or duplicating exactly what was being sung. In other words, it was accompaniment in the purest sense of the word.

Often the orchestra became expressive in its own right, and diverged from the vocal lines to create an added layer of interest. Orchestral writing was occasionally used to paint pictures even without the benefit of words. If one knew the context it became easy to understand how the instrumental underlayment was portraying the character of the text.

The challenge for the listener is to embrace *both* the vocal and instrumental components as equal partners, and attempt to let the orchestral writing enhance and express the deepest meaning of the texts.

6

COMPOSITIONAL DEVICES

WORD PAINTING

Simply reading the *Messiah* texts as a devotional guide or hearing them in a discourse or sermon would be sufficient to our understanding. Readers and orators have presented these truths countless times; even in Jennens' England most people were acquainted with them. To convey the orthodoxy of the Christian faith was Jennens' purpose, but he wanted to go further than mere pulpit discourse. His inspired plan was to refresh the familiar texts by surrounding them with the musical genius of Handel.

Music has power; Jennens, having previously collaborated with Handel, knew it. Music is capable of reaching the deepest recesses of the human spirit where no other art or language can go. Music can achieve this even without words; it communicates in its own unique way.

Words also have their own unique power. To create a fusion between words and music is to unite them in a symbiosis, an aesthetic or artistic "chemistry," where the result produces an effect greater than the sum of the two parts.

Symbiosis is achieved when the music "paints" a picture that enhances the meaning of the text. This has always been the desire of composers, never more so than in the Baroque period. They referred to it as *word painting*, or *text painting*. Sometimes the result is simple and obvious; other times it can be more complex. Sometimes the text needs to be the master; other times the text steps aside and lets musical word painting carry the emotion the text implies. Numerous examples exist in *Messiah*, and the most significant will be discussed.

MELISMAS

The Merriam-Webster Dictionary definition of *melisma* is "a group of notes or tones sung on one syllable in Plainsong; melodic embellishment."[1] Historically, melismas have been used as far back as musical research can take us. The church in the West incorporated the expressive practice in *plainchant* or *plainsong* throughout monastic societies as well as in local community worship. Melismas serve multiple purposes. The most perfunctory is to increase the length of the composition, or a movement within the composition. Pure syllabic writing, one note for each syllable, obviously results in the shortest possible rendition of the text. "Melodic embellishment" creates an attractive musical line, a delight for both the singer(s) and the listener(s). Words are expanded or lengthened by adding multiple notes on one or more syllables. This, too, is a basic application of melisma.

The Baroque period saw yet another possibility: a narrowing of usage, primarily applying melismas to words that expressed joy, delight, or hope. As a general practice in *Messiah*, one should examine the words given to melismatic

1. *Merriam-Webster*, s.v. "melisma (*n*.). https://www.merriam-webster.com/dictionary/melisma.

writing in order to understand the sheer exuberance the composer has intended. In *Messiah*, one of the first words given a melismatic setting is "exalted," coming at the end of the phrase "every valley shall be exalted." It fits the criteria of joy, delight, and hope. Many similar examples occur throughout the oratorio.

Even when the word being sung in a melismatic setting seems, on the surface, to suggest a contrary or negative sentiment, one must seek the positive ramification. An example is "Thus saith the Lord of Hosts: Yet once a little while and I will shake the heavens and the earth." A long melisma is attached to the word "shake," suggesting bad news for those opposed to God, but good news for his followers. In the same bass aria another melisma is coupled with the word "desire" in "the Desire of all nations shall come." "Shake" and "desire," two seemingly opposed sentiments, are united by Handel into a composite delight, joy, and hope of God's followers. Throughout *Messiah* melismas abound and should be understood in that exuberant light.

MAJOR AND MINOR KEYS

It is generally simplistic to see major keys as *positive* or *bright* and minor keys as *negative* or *dark*. Such a notion is fairly and rightly applied throughout *Messiah*. Handel frequently uses major keys to indicate *light* and minor keys to indicate *shadow*. When confronting a generally positive text set in a minor key, or a negative text set in a major key, one must then ask: "Why?" There will always be an underlying reason based upon either future outcomes or historical precedents as discovered in the Scriptures. When such situations occur in *Messiah* we will attempt to give explanations.

PART THE FIRST

(The Anticipated Redemption: Prophecy)

According to the Hebrew Scriptures, Adam's disobedience in the garden of Eden caused the fall from creation's perfection. God's "chosen people" began looking for a Redeemer, a messianic figure who would establish a new kingdom on earth. They searched their Scriptures. Based upon their interpretations of all the prophets, they believed their Messiah would come as a conquering hero to destroy God's enemies, set up his kingdom, rule benevolently, and judge righteously. He would bring both physical and spiritual healing to the nation.

Part the First introduces such a King as this, with one great surprise; he would come as an infant. Words of the "virgin birth" are tucked into the middle of *Part the First* between the prophetic descriptions of Messiah as a conquering hero and the images of Messiah as a compassionate healer.

Apart from the jarring news of a virgin and an infant, the texts of *Part the First* meet all of Israel's expectations. The kingdom was coming; God's rule would be established on earth.

Jennens' compilation of the Scripture texts for *Part the First* pays homage to Israel's anticipated messianic hopes. However, he knew the story would evolve into something far more demanding and tragic, challenging the hopes and dreams of God's "chosen people."

Handel also knew the tragic and blessed consequences destined to unfold. He gives us musical clues to Messiah's tragic future, even from the very first chord of the *Sinfony*.

7

SCENE 1:

THE WORLD AFTER THE FALL

#1
Sinfony
Affect: "e minor"
Lament, Sighs, Tears
Grief, Mournfulness, Restlessness

HANDEL'S SINFONY (IN ITALIAN, *Sinfonia*) follows the form of the *French Overture*. It has two parts: a slow, stately beginning, often repeated, marked by dotted rhythms, followed by a lively fugue. Occasionally, a brief addition to the fugue brings back either the character or melodic theme of the beginning, again in stately form.

A question arises immediately upon hearing the first *e minor* chord: Why did Handel choose a minor key generally, or e minor specifically? One would assume that an oratorio depicting the coming of Messiah would be heralded by a

major key, the *bright* side of the musical equation. Handel chose a minor key, the *dark* side.

What is he telling us? Is the Sinfony both a look back and a look ahead? Looking back, one considers the disobedience in the garden of Eden that will require messianic intervention. Looking ahead, a blood sacrifice will be needed to cover the sin of Adam. E minor's affect of lament, sighs, tears, grief, mournfulness, and restlessness is the first awareness of humanity's great need, leading to the terrible price redemption and a return to Eden will require. One doesn't need words to understand the dark and ominous tone established by the first musical phrase.

The only other movement in *Messiah* set in the affect of e minor is #30, the tenor aria "Behold and see if there be any sorrow like unto my sorrow." It looks back and provides a direct link to the Sinfony, validating the affect by giving words to the Sinfony's wordless spirit. Sorrow in the tenor aria is what the dark Sinfony was pointing toward. One must always look for such links of affect, as they almost always point to the greater truths being revealed.

8

SCENE 2: THE PROMISE

<div align="center">

#2
Tenor-Accompanied Recitative
Comfort ye, comfort ye my people, saith your God; speak ye
comfortably to Jerusalem;
and cry unto her, that her warfare is accomplished, that her
iniquity is pardoned.
The voice of him that crieth in the wilderness,
Prepare ye the way of the Lord, make straight in the desert a
highway for our God.
(Isa 40:1–3)
Affect: "E Major"
Joy, Pleasure, Delight

</div>

THE NORMAL MUSICAL/COMPOSITIONAL PRACTICE following a minor key is either to stay in that same key or move to its relative major key, one that shares the same key signature. In this case the e minor of the Sinfony, with one sharp, shares that same sharp with G Major, whose affect reads: *Every gentle and peaceful emotion of the heart.* That would certainly have been an appropriate affect for this text proclaiming comfort and forgiveness to the people.

Handel chose a different path; he didn't move from dark e minor to the light of its relative G Major. Nor did he stay in the totally inappropriate e minor (lament, sighs, tears). Instead, he chose unrelated E Major (four sharps rather than one). Why? Was he asserting that the dark side of E (the minor side) is being *transformed* into something hopeful and bright (the major side of the same key)? Was he consciously pointing to the joy, pleasure, and delight that redemption and transformation will bring to an otherwise hopeless world? Traditional compositional practices have been set aside for a higher purpose. The face of "E" has moved out from the *shadows* into the *coming illumination* the advent of Messiah will bring. Handel's action, moving from the dark to the bright side of the same key, was one of *musical transformation.*

Spiritual transformation is the goal of the coming Messiah. According to Christian theology those who embrace him and his message will be changed: same flesh, different spirit. In essence, their e minor dark side existence will become transformed into the bright side of E Major. In a bass aria near the end of *Messiah*, the spiritual transformation hinted at here and throughout the entire composition will become complete: (#48) "We shall be changed—the corruptible will become incorruptible." What Handel did in this opening recitative reveals his thorough understanding of the transformational essence of Scripture. This is the first of several transformations Handel describes.

Such transformational speculation is borne out by the only other uses of E Major in *Messiah*: (#3) "Ev'ry valley shall be exalted" (which follows this recitative), and the soprano aria (#45) "I know that my Redeemer liveth" that begins *Part the Third*. In all three instances the affect of E Major ("joy, pleasure, delight") is the most suitable response. They exult over the first coming (the birth of Messiah) and the

second coming (the rebirth or resurrection of Messiah). According to Christian theology God's intervention into the human dilemma provides the basis for redemption, reconciliation, and transformation.

"*Comfort Ye*" are the first words we hear, breaking the silence of a broken world. They appear without orchestral accompaniment as if to highlight their significance. Stated three times, always in a downward trajectory, they are the first instances of word painting: comfort will come from heaven above to earth below. With "comfort ye" the oratorio begins its journey to answer the dilemma posed by the Sinfony.

FIGURE 1

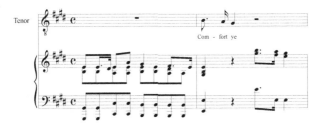

Example 1: Recitative, Tenor, "Comfort Ye My People"

The accompanied recitative abruptly gives way to a secco (dry) recitative (#2), "The voice of him that crieth in the wilderness, Prepare ye the way of the Lord, make straight in the desert a highway for our God." It forms a bridge to the following aria.

#3
Tenor Aria

Every valley shall be exalted, and every mountain and hill made low;
the crooked straight, and the rough places plain.
(Isa 40:4)

The theme of transformation continues in the same E Major (Joy, Pleasure, Delight) of the preceding recitative. The aria presents the first instances of Handel's use of melisma.

FIGURE 2

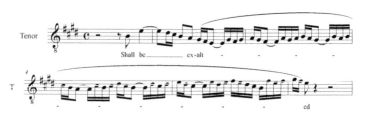

Example 2: Air for Tenor, "Every Valley Shall Be Exalted,"
excerpt, "shall be exalted"

Melismatic exuberance is well suited for the word "exalted" that dominates the aria, occurring four times. These melismas are inserted between episodes of word painting on the phrases, "every mountain and hill made low," and "the crooked straight and the rough places plain." If one draws a line connecting the notes in these musical statements, a perfect visual impression of mountains and valleys leaps off the pages. They are among the most obvious examples of word painting in the entire Baroque period.

FIGURE 3

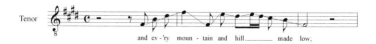

Example 3: Air for Tenor, "Every Valley . . .," excerpt,
"and every mountain and hill made low"

FIGURE 4

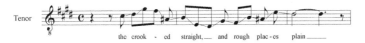

Tenor

the crook - ed straight,__ and rough plac - es plain__

Example 4: Air for Tenor, "Every Valley . . .," excerpt,
"the crooked straight"

<h3 style="text-align:center">#4</h3>

Chorus

*And the glory of the Lord shall be revealed, and all flesh shall see
it together;
for the mouth of the Lord hath spoken it.
(Isa 40:5)*
Affect: "A Major"
Hope of Seeing One's Beloved Again, Trust in God

The *A Major* affect fits Isaiah 40 perfectly. The Lord
has made a promise: the Beloved One will be revealed.
Handel could have composed this Isaiah passage in the
same E Major as the preceding recitative and aria, whose af-
fects were joy, pleasure, and delight; such a response would
have been appropriate. It seems clear that Handel wanted
an affect implying greater individuality, clarity, assurance,
and certainty: *trust* and *hope*.

Again, the affect is linked with a passage of fulfillment
later in the oratorio: (#32) "But Thou didst not leave his
soul in hell." The tenor aria uses the same affect of A Major,
thus cementing the certainty of our future hope; we will
see the Beloved One, just as God has promised in this text.
These are the only two uses of A Major in the entire work,
giving great weight to the argument of affect intentional-
ity: *messianic revelation* in the first instance, and *messianic
resurrection*, the hope of humanity, in the second.

Word painting is achieved in this chorus by the trajectory of the melodic phrases. The upward musical line "And the glory of the Lord" is counterbalanced by the downward music line accompanying "shall be revealed." This is consistent throughout the chorus.

FIGURE 5

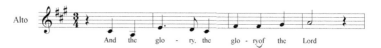

Example 5: Chorus, "And the Glory of the Lord,"
excerpt "And the glory . . ."

FIGURE 6

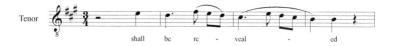

Example 6: Chorus, "And the Glory of the Lord,"
excerpt, "shall be revealed"

The stentorian acclamation "for the mouth of the Lord hath spoken it" is stately and rock solid on a single pitch each time it is proclaimed, embodying the unwavering and trustworthy voice of God as promised in the Isaiah text.

FIGURE 7

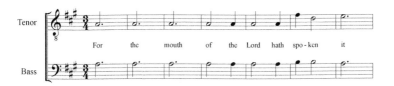

*Example 7: Chorus, "And the Glory of the Lord,"
excerpt, "for the mouth of the Lord"*

SCENE 3:

SHAKING UP THE WORLD

#5

Bass Recitative

Thus saith the Lord of Hosts:
Yet once a little while and I will shake the heavens, and the earth,
the sea, and the dry land;
and I will shake all nations, and the desire of all nations shall come.
(Hag 2:6–7)
The Lord whom you seek, shall suddenly come to his temple,
even the messenger of the covenant, whom ye delight in.
Behold, he shall come, saith the Lord of Hosts.
(Mal 3:1)
Affect: "d minor"
The Dark Side and Opposite of Calm and Complacent
"F Major"'

ALL THREE MOVEMENTS IN the preceding section, Scene 2: *The Promise*, were in major keys vividly expressing the bright side of the coming redemption. The next three movements are in minor keys, the dark side and shadows.

Before the *Desire of all nations* comes, the entire creation will be put to the test. Redemption demands a price; there will be an accounting.

Baroque composers used rapid musical passages and disjointed melodic lines to depict fury, exactly the device Handel employed in this recitative. In addition, he used melismas on two words: "shake" and "desire." As we have stated, the general rule is that melismas express something positive, bright, or hopeful. One questions the melisma on "shake" unless it is seen as a necessary precursor to the advent of "the desire of all nations" as stated in the Haggai text. Assuming this viewpoint, shake and desire become united in a single act of preparation and deliverance. Handel seems to have intentionally used melismas to confirm their union.

FIGURE 8

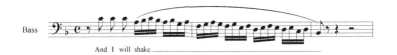

Example 8: Recitative for Bass, "Thus Saith the Lord,"
excerpt, "and I will shake . . ."

FIGURE 9

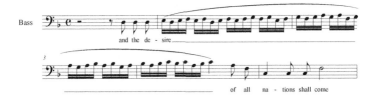

Example 9: Recitative for Bass, "Thus Saith the Lord,"
excerpt, "and the Desire of all nations shall come"

37

Handel's use of agitated, dotted rhythms in this recitative is the first instance since the opening Sinfony. In total six movements are marked by this characteristic, and they appear to have much in common. The first, in the Sinfony, prepares the listener for the suffering that will transpire on the journey to redemption. The second, "Thus saith the Lord," suggests the turmoil to be experienced by creation and its inhabitants.

FIGURE 10

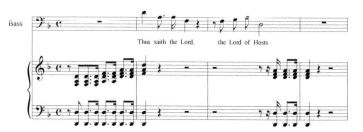

Example 10: Recitative for Bass, "Thus Saith the Lord,"
Orchestral excerpt, dotted rhythms

The next three will open *Part the Second* and more directly depict the One who comes and endures suffering on our behalf: (#22) "Behold the Lamb of God"; (#23) "He gave his back to the smiters"; and (#24) "Surely he hath borne our griefs."

The sixth and final movement marked by agitation and dotted rhythms is the only one in a major key: (#48) "The trumpet shall sound." It appears to reverse the dark side embraced by the first five and summarizes the resurrection outcome of all that Messiah endures. Handel's singular use of that one major key suggests that even agitated, dotted rhythms, and the fury they represent, can be transformed. Isolating the six texts, and reading them as one entity, these dotted rhythm movements can be seen as a synopsis,

covering in abbreviated fashion the same landscape as the whole composition: *The Fall, The Sacrifice, Resurrection, and Eternal Life*:

#1 Sinfony
#5 Bass Recitative

Thus saith the Lord of Hosts:
Yet once a little while and I will shake the heavens, and the earth,
the sea, and the dry land;
and I will shake all nations, and the desire of all nations shall come.

(Hag 2:6–7)

#6
Bass Aria

But who may abide the day of his coming, and who shall stand
when he appeareth?
For he is like a refiner's fire.

(Mal 3:2)

#22 Chorus

Behold the Lamb of God, that taketh away the sins of the world.

(John 1:29)

#23 Alto Aria

He was despised and rejected of men: a man of sorrows, and
acquainted with grief.

(Isa 53:6)

#24 Chorus

Surely he hath borne our griefs, and carried our sorrows;
He was wounded for our transgressions; he was bruised for our
iniquities;
the chastisement of our peace was upon Him.

(Isa 53:4–5)

#48 Bass Aria with Trumpet

The trumpet shall sound, and the dead shall be raised incorruptible,
and we shall be changed.
For this corruptible must put on incorruption, and this mortal
must put on immortality.

(1 Cor 15:52–53)

The aria continues in both the spirit and affect of the preceding recitative and is divided into two sections, A and B. The A section asks provoking questions: "Who may abide the day of his coming?" and "Who shall stand?" The B section states the reason for the dilemma: "For he is like a Refiner's fire." It is in the B section that Handel mimicked the fury of the preceding recitative through the rapid pace of the orchestra and the expansive melodic line. "Refiner's fire" is set in an exuberant melisma that seems appropriate given the eventual purifying result of his refining, as stated in the chorus that follows.

#7

Chorus

And he shall purify the sons of Levi
that they may offer unto the Lord an offering in righteousness.
(Mal 3:3)
Affect: "g minor"
Discontent, Uneasiness, Worry about a Failed Scheme

Malachi's Scripture passages reflecting the *shaking up of the world* are brought to completion in this chorus. Handel chose to set it in a different minor key, when d minor would have sufficed to lend unity to the two texts. G minor (discontent, uneasiness, worry about a failed scheme) seems more fitting in its specificity of affect than d minor, which is more general in its dark shadow.

The "sons of Levi" were the chosen tribe of priests responsible for offering sacrifices to the Almighty. Handel set the process of sacrificial purification in a minor key, suggesting that a price will be extracted from those initiating the purification process. By virtue of its minor-key setting, it appears the melisma on "purify" serves two purposes: to reveal both the dark side of the cost that is being foreshadowed (the minor key), and the bright side of its purpose (the melisma).

The affect of g minor is used four times in the oratorio. This is the first, depicting the price to be paid by the sons of Levi. The next (#22) begins *Part the Second* and focuses on the Lamb of God whose costly sacrifice will replace the rituals offered by the sons of Levi. The final two, (#38) "How beautiful are the feet of them that preach the gospel of peace" and (#52) "If God be for us who can be against us?," describe the costly price to be paid by the apostle martyrs in the New Testament.

For the moment we have been caught up in the costliness of discipleship. This foreshadowing, however dark, is soon to be lost in the light of the good news that follows.

10

SCENE 4: FIRST WORDS
OF A VIRGIN BIRTH

JENNENS LEAVES MALACHI'S PREDICTIONS and returns to Isaiah's prophecies. Handel introduces the key of D Major, the most significant and symbolic key of the entire *Messiah*. Its affect is "Triumph, War Cries, Victory, Rejoicing, and Hallelujahs." A total of eleven movements are in D Major, far more than in any other key:

> *Behold, a virgin shall conceive*
> *O Thou that tellest good tidings to Zion*
> *And suddenly there was with the angel*
> *Glory to God*
> *Let all the angels of God worship Him*
> *Hallelujah*
> *Behold I tell you a mystery*
> *The trumpet shall sound*
> *Worthy is the lamb that was slain*
> *Blessing and honor*
> *Amen*

All the *heaven-rejoicing recitatives, arias,* and *choruses* are set in D Major, and constitute the means of redemption Jennens and Handel set out to achieve. Contained within these eleven movements are the following themes:

- The prophecy of the birth of Messiah
- The angel chorus announcing his birth
- The proclamation "King of kings, and Lord of lords" after the defeat of God's enemies
- The resurrection of all believers
- The gathering around the throne of the Lamb in the end times.

"Triumph, War Cries, Hallelujahs, Victory, and Rejoicing" fits each of them perfectly.

#8
Alto Recitative
Behold, a virgin shall conceive, and bear a Son,
and shall call his name EMMANUEL, God with us.
(Isa 7:14; Matt 1:23)
Affect: "D Major'
Triumph, War Cries, Hallelujahs, Victory, Rejoicing

Handel's music for this miraculous prophecy, which sets in motion the course of action for the world's redemption, is surprisingly terse and understated. Set as a secco recitative, the orchestra is reduced to a few simple chords and little action. The fact that this is the first use of secco recitative in the oratorio since (#2), "Prepare ye the way of the Lord" (textually related to this prophecy of Messiah's birth), focuses even greater attention on the importance of the text.

FIGURE 11

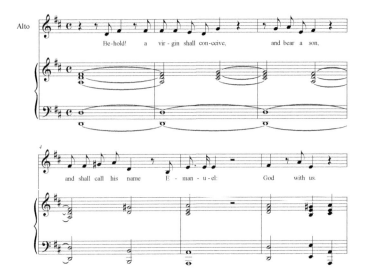

Example 11: Recitative for Alto, "Behold, a Virgin Shall Conceive"

Except for one note the recitative's melodic line is contained within a range of five notes—even medieval plainchant was more elaborate than this! The declamatory text is revealed simply, one note for each syllable, without a steady pulse or rhythm. It seems to hang suspended above all the action surrounding it, with no melismas and no word painting. The choice of an alto soloist is also surprising and underwhelming. One would have expected the lively, bright tessitura a soprano or tenor could bring to this announcement that will change the future of humanity.

Handel presented the virgin birth without fanfare. Six brief measures: no grand rhetoric attempting to convince a disbelieving world through sheer verbosity. With all the expansive elaboration that has come before, such understatement is not only a relief, but causes the recitative to

stand out *because* of its rather "unmusical" nature. In view of the Enlightenment's attacks on the miraculous, Handel's understated restraint exhibits great confidence, assurance, and certainty.

<div align="center">

#9
Alto Aria and Chorus

</div>

O thou that tellest good tidings to Zion, get thee up into the high mountain;
O thou that tellest good tidings to Jerusalem, lift up thy voice with strength;
lift it up, be not afraid; say unto the cities of Judah, Behold your God!
(Isa 40:9)
Arise, shine, for thy light is come
and the glory of the Lord is risen upon thee.
(Isa 60:1)

<div align="center">

Affect: "D Major"
Triumph, War Cries, Hallelujahs, Victory, and Rejoicing

</div>

In contrast to the stunning simplicity of the virgin birth prophecy, Handel treated this aria in a more typical, straightforward manner. The affect of "triumph, war cries, hallelujahs, victory, and rejoicing" carries the essence, assisted by two melismas on "mountain" (the location of God) and "glory" (the praise he deserves). There are no melodic surprises, nor is there any hint of word painting, though the text gives ample opportunity for such picturesque rendering. The text says everything that is necessary: "the glory of the Lord is risen upon thee." The chorus repeats the enthusiastic refrain.

<div align="center">

#10 & 11
Bass Recitative and Aria

</div>

Recitative: For, behold, darkness shall cover the earth, and gross darkness the people,

*but the Lord shall arise upon thee, and his glory shall be seen
upon thee,
and the Gentiles shall come to thy light, and kings to the bright-
ness of thy rising.
(Isa 60:2–3)
Aria: The people that walked in darkness have seen a great light:
and they that dwell in the land of the shadow of death, upon
them hath the light shined
(Isa 9:2)*
**Affect: "b minor"
The "dark side shadows" of "D Major"**

The light the coming Messiah will bring, just an-
nounced by the alto soloist and chorus, is interrupted by
words of darkness. D Major brightness gives way to the
darkness of its relative b minor. The light-and-shadow
effect Handel employed reflects perfectly the contrast be-
tween the two texts: the brightness of the future as opposed
to the darkness of the present.

FIGURE 12

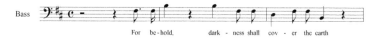

*Example 12: Recitative for Bass, "For Behold, Darkness Shall Cover
the Earth," excerpt on "darkness."*

It is only a short excursion into darkness. The phrase
"For behold, darkness shall cover the earth, and gross dark-
ness the people" is interrupted by words of the Lord's glory
as the music symbolically returns to D Major.

FIGURE 13

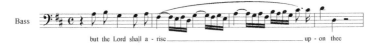

Example 13: Recitative for Bass, "For Behold, Darkness Shall Cover the Earth," excerpt, "but the Lord shall arise upon thee"

The recitative delineates the two worlds—the world of darkness and the rising of the Lord and his glory—by placing them in contrasting registers. "Darkness" inhabits the lower realm of the bass tessitura, and "glory" the upper realm. "Darkness" is also depicted in a disjointed melodic line, with great skips and leaps between notes. As we have stated, Baroque composers often depicted anxiety and fury in this manner. Conversely, "glory" is revealed through a contrasting contour of melodic smoothness. The words "arise" and "glory" are set in joyful melismas.

The aria (#11) "The people that walked in darkness" continues the contrasts between darkness and light, with "darkness" either placed low in the vocal line or in a downward trajectory. Its disjointed melodic line is always set in a minor key. Again, as in the recitative, light occupies the singer's upper register and is contained within a smooth contour, always in a major key.

Handel's tonal byplay—alternating between major and minor, agitated and smooth—showcased the shadow effect of a world in need in contrast with the brightness of the coming salvation.

Here, for the first time, the assembled texts sung by the bass refer to a broadening of Messiah's kingdom, extending beyond the children of Israel, encompassing the gentile world as well. Every tribe and nation, every ethnic and social strata, will be affected by Messiah's coming.

#12
Chorus

For unto us a Child is born, unto us a Son is given,
and the government shall be upon his shoulder:
and his name shall be called Wonderful Counselor, the Mighty
God
the Everlasting Father, the Prince of Peace.
(Isa 9:6)
Affect: "G Major"
Every Gentle and Peaceful Emotion of the Heart

Handel borrowed the music for this chorus from a chamber duet he had previously composed, a self-plagiarizing practice undertaken by numerous Baroque composers. It is one of four such borrowings in *Messiah*. The others are: (#7) "And he shall purify," (#26) "All we like sheep," and (#21) "His yoke is easy." Ironically, the text of this borrowed secular chamber duet stated the distrust of the false god of love in contrast to the Isaiah text employed here!

This chorus reveals the compositional style of Handel. While not completely abandoning the purely Baroque style, he nonetheless moved away from the exclusive contrapuntal *polyphonic* style of the past toward the more chord-based, vertical rendering of the future. This new *homophonic* style placed the more important melodic line on top, with the other voices serving it, similar to a Greek temple: a *melodic roof* supported by *harmonic pillars*. The underlying voices often shared the same rhythms and word syllables simultaneously with the melody, a technique that is profoundly demonstrated in this chorus. On these pages Handel alternated between the two styles—polyphonic and homophonic—to great effect.

FIGURE 14

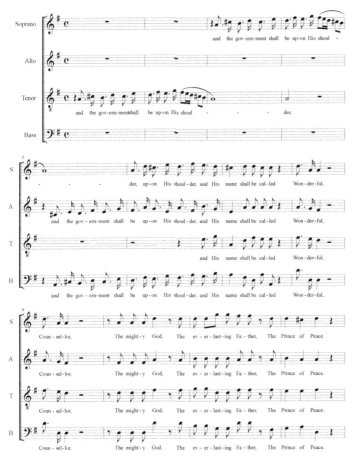

*Example 14: Chorus, "For Unto Us a Child Is Born," excerpt
demonstrating polyphony and homophony*

The phrase "Wonderful Counselor, the Mighty God,
the Everlasting Father, the Prince of Peace" is stated in clear
and powerful vertical, rhythmic, and syllabic homophonic
uniformity each time it occurs. The words are sung just as

they would be spoken. Absolute clarity is achieved through this forthright declaration of the character, attributes, and future reign of the coming Messiah. This text is preceded and followed by passages of polyphony, thus putting it into an even greater spotlight or relief. If one understands this juxtaposition of compositional styles, one more greatly understands Handel.

The extensive use of lengthy melismas on the word "born" lends exuberance almost unequaled in the rest of the oratorio. They heighten the contrast with the syllabic utterances of Messiah's character.

This is the only appearance of G Major in the entire composition. Fittingly, its description of the coming Messiah's attributes—"Every gentle and peaceful emotion of the heart," depicted in homophonic settings—indeed stands alone. He is like none other, as the singular use of G Major suggests.

The G Major affect culminates Scene Four, which has been dominated by the D Major affect of "triumph, war cries, hallelujahs, victory, rejoicing." G Major is an unexpected deviation from the equally appropriate D Major, yet it proves to be the most fulfilling musical gesture precisely because of its singularity and identification with Messiah.

11

SCENE 5: INTO THE SHEPHERDS' FIELD

AN ORCHESTRAL INTERLUDE INTERRUPTS Isaiah's prophecies and takes us to the quietness and serenity of the shepherds' field near Bethlehem. History is about to turn. Angel voices disturb the silence with their message, rocking the world of their startled observers. The scene goes by quickly. These are the only Christmas texts in the entire work, and they are done simply: no major aria—only four recitatives and a chorus.

#13
Pastoral Sinfony
Affect: "C Major"
Purity, Innocence, Simplicity

Apart from the opening Sinfony, the *Pastoral Sinfony* (sometimes called *Pifa*) is the only instrumental interlude in *Messiah*. Baroque composers often set pastoral scenes the way Handel set his. The first clue to the peasant nature

of the shepherds is the employment of the *drone*, a long-held note undergirding the composition. Its bagpipe-style characteristic has been associated with the countryside and the peasantry throughout musical history.

FIGURE 15

Example 15: "Pastoral Symphony," excerpt, the drone

Another clue is the use of the meter signature 12/8. It, too, was frequently used to paint musical portraits of the peasantry and nature.

God becoming flesh defies logic and reason as well as our expectations. Messiah came not as the conquering hero they had anticipated, but rather as an innocent baby in a manger. Citadels of power and the halls of global influence were ignored in favor of a simple, rustic, anonymous shepherds' field. Who would have expected such a stage for the world-changing announcement about to be made?

#14
Soprano Recitative
There were shepherds abiding in the field, keeping watch over their flocks by night.
(Luke 2:8)
Affect: "C Major"
Purity, Innocence, Simplicity

Handel reserved the soprano soloist for this moment. Since the opening tenor recitative and aria, only the alto

and bass have been heard, with the bass predominating. The contrast between the lowest human voice of each gender and the sudden appearance of the soprano is powerfully symbolic, bringing heavenly light into the dark world of the shepherds.

The soprano quietly and unsuspectingly intrudes into, and grows out of, the serenity of the shepherds' field as depicted in the Pastoral Sinfony. Her appearance is marked by the same C Major world of purity, innocence, and simplicity. The same drone underlies her picturesque, almost whispered commentary. In four short measures, thirteen beats, the portrait is painted: shepherds, sheep, fields, night.

FIGURE 16

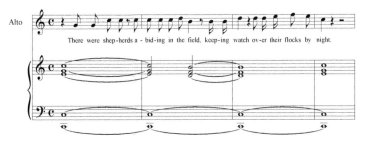

Example 16: Recitative for Soprano, "There Were Shepherds"

#15
Soprano Recitative
And lo! The angel of the Lord came upon them,
and the glory of the Lord shone round about them, and they
were sore afraid.
(Luke 2:9)
Affect: "F Major"
Calm

The serenity of the Pastoral Sinfony and the first recitative are shattered. The violins play twenty-three lively upward-moving four-sixteenth-note patterns. Was Handel trying to paint an image of fluttering wings?

FIGURE 17

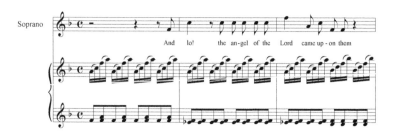

Example 17: Recitative for Soprano, "And Lo! The Angel of the Lord Came Upon Them," excerpt, violin "fluttering wings"

F Major is used only three times in *Messiah*, and each time the texts focus on shepherds or sheep. In addition to the recitative quoted above, the other two are: (#20) "He shall feed his flock like a shepherd" and (#26) "All we like sheep have gone astray." In this second soprano recitative the affect is F Major calm, perhaps intended to counteract the final phrase of the text where the soprano reveals that the shepherds were sore afraid.

#16
Soprano Recitative
And the angel said unto them,
Fear not for, behold, I bring you good tidings of great joy, which shall be to all people.
For unto you is born this day in the city of David a Savior, which is Christ the Lord.
(Luke 2:10–11)
Affect: Multiple

Pregnant with textual significance, this nine-measure recitative is musically transitional, and moves through a variety of tonal centers (A Major, D Major, E Major, B Major, C# Major, and finally f# minor). Handel's journey through this complicated transition of keys, all for the purpose of arriving at D Major, is puzzling. He arrived in D Major early, then left it for a longer, circuitous route back to that same key of "Triumph, War Cries, Hallelujahs, Victory, and Rejoicing" in the soprano's final recitative. Was he trying to create distance between the world's need and the announced source of remedy, depicting the vast chasm about to be bridged? Was he portraying the unsettling and radical nature of the message? Whatever his reason, the theoretically jarring movement through six keys in nine measures is veiled in a peaceful and simple secco recitative! The same quiet assurance was previously expressed in the alto recitative (#8), "Behold, a Virgin Shall Conceive," thus linking the two recitatives: prediction and fulfillment.

#17
Soprano Recitative and Chorus
And suddenly
there was with the angel a multitude of the heavenly host praising God, and saying:
(Chorus) Glory to God in the highest, and peace on earth, good will towards men.
(Luke 2:13–14)
Affect: "D Major"
Triumph, War Cries, Hallelujahs, Victory, Rejoicing

Once again, the four-sixteenth-note fluttering of angel wings is heard. Stated thirty times in a violin duet, the soprano tells of a multitude of the heavenly host praising God, leading to the chorus of angels in their D Major affect singing "Glory to God."

Word painting and orchestral mood painting abound. The homophonic "Glory to God" reaches vocal heights accompanied by rapid orchestral passages that add brilliance to the phrase. The homophonic "Peace on earth" reaches downward, with the orchestra mimicking the voices. The polyphonic setting for "Good will towards men" implies multitudes of tribes and nations.

FIGURE 18

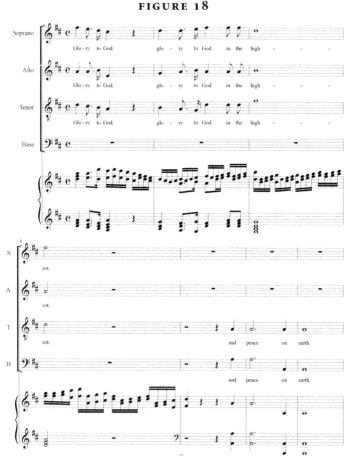

Example 18: Chorus, "Glory to God," opening statement

Whether or not Handel included dynamic markings in his original score, it is the current practice of published editions to include them, to great effect in this chorus. The markings begin *piano*, and gradually increase to *fortissimo* at the midpoint of the chorus. Then the process is reversed as the angels and the orchestra both recede into *pianissimo* at the end. In this short chorus Handel has portrayed the curtain of heaven opening, pouring itself out, and once again becoming veiled from our sight.

In this scene, Scripture passages from the New Testament (Luke 2) have intruded on the Old Testament prophecies, just as the angels of the coming new world have intruded into the old world pastoral scene of the shepherds. It is a brief intrusion, taking fewer than four minutes, yet the world is changed forever.

On the basis of this short episode many tend to think of *Messiah* as a Christmas work. That was not the intention of Handel and Jennens.

12

SCENE 6: FOUR IMAGES OF A SAVIOR

A Healer Who Doesn't Suffer

PART THE FIRST ENDS with four movements in major keys, reflecting the prophecies of a conquering hero Messiah. Suffering and death were not part of the Jewish messianic equation, and they are avoided in these descriptions. Messiah, it was thought, would come from God, destroy God's enemies, set up his kingdom, and rule. He would reign as a beneficent King, a righteous Savior worthy of adoration and great rejoicing, and a healer of the lame, the deaf, and the blind.

Handel accomplished his compositional task by bookending this four-movement section in the key of Bb Major, whose affect evokes "aspirations for a better world pictured by a gentle Jesus." The affect fits the texts perfectly. However, Handel also knew of the suffering to come in *Part the Second*. He seems to have used these very strong texts served by major keys spread over nearly forty pages in the

choral score to set up a great contrast to the coming truth about to be told: Messiah *will* suffer and die. But for now that remains hidden by our messianic expectations.

#18
Soprano Aria

Rejoice greatly, O daughter of Zion; shout, O daughter of Jerusalem:
behold, thy king cometh unto thee.
He is the righteous Savior, and he shall speak peace unto the heathen.
(Zech 9:9–10)
Affect: "Bb Major"
Aspirations for a Better World, A Picture of a Gentle Jesus

Rejoice appears sixteen times, most of them set in melismas. The sheer magnitude of rejoicing shuts out any thought that the Savior is anything but a welcome King whose reign will be marked by a much-desired peace.

The soprano, bearer of this joyous message, is the same voice that heralded the birth of Messiah through the recent songs of the angel. Her aria is a simple structure: a middle section reflecting on the peace he will bring surrounded by the great rejoicing of Zion and Jerusalem.

#19 & 20
Alto Recitative; Alto Aria

Then shall the eyes of the blind be opened, and the ears of the deaf unstopped;
then shall the lame man leap as an hart, and the tongue of the dumb shall sing.
(Zech 35:5–6)
He shall feed his flock like a shepherd;
and he shall gather the lambs with his arm, and carry them in his bosom,
and gently lead those that are with young.
(Isa 11:11)
Affect: Transitional and "F Major"
Calm

The alto parallels her previous recitative (#8) that quietly heralded the miracle of the virgin birth. The opening three notes bridge the same *D–F#* interval as "Behold, a virgin shall conceive"; the union between the two recitatives is inescapable. The virgin's offspring will be the great healer.

FIGURE 19

Example 19: Recitative for Alto, "Then Shall the Eyes of the Blind Be Opened," first statement

She sings of the miracles the Savior will bring as he heals the blind, the deaf, the lame, and the dumb. In both recitatives the settings' simplicity stands in stark contrast to the miraculous nature of the texts. Again, the orchestra is almost static while the singer intones the text in a limited vocal range and syllabic declaration. It seems important to link these two recitatives as intentional supernatural manifestations: the virgin birth and Messiah's miraculous healings. They are set in the same understated fashion and begin with the same *D–F#* interval, using the same alto soloist.

"Then shall the eyes of the blind" flows directly into the alto's first aria, "He shall feed his flock like a shepherd, and he shall gather the lambs with his arm." Once more, the affect of F Major calm hovers over the text. It was previously stated that F Major in Handel's *Messiah* is always related to sheep and shepherds, as is the case here. There is a further link with shepherds and sheep through the 12/8 meter used earlier in the Pastoral Sinfony.

#20 Continued
Soprano Aria

Come unto Him, all ye that labor and are heavy laden, and he
shall give you rest.
Take his yoke upon you, and learn of Him; for he is meek and
lowly of heart:
and ye shall find rest unto your souls
(Matt 11:29).
Affect: "Bb Major"
Aspirations for a Better World, A Picture of a Gentle Jesus

As was true of the alto's aria, the soprano continues in the same smoothly flowing, melodic style. The vast majority of notes touch each other in scale-like sequence (124 out of 140, with only sixteen skips between notes) in a compelling gentleness hardly present elsewhere in *Messiah*. The overall serenity of these two arias paints a tonal landscape otherwise devoid of word painting. The same melodic line serves both arias, the differences being text, vocal range, and affect.

Did Handel intend the consequence an affect change from F Major to Bb Major between the two soloists would elicit? He could easily have given both texts to either the alto in F Major or the soprano in Bb Major. What purpose was served by his treatment?

The Bb Major hope of "aspirations for a better world, a world made better by a gentle Jesus" links the two soprano arias that begin and end the scene. Even though they unfold with differing characteristics—one exuberant, the other gentle—their affects are the same. The alto recitative and aria, by virtue of their being in the calm affect of F Major, identified with sheep and shepherds, seem only to serve as a reminder that a Good Shepherd was to be the source of all comfort and healing.

#21
Chorus
His yoke is easy, and his burden is light.
(Matt 11:30)
Affect: "Bb Major"
Aspirations for a Better World, A Picture of a Gentle Jesus

As with the previous soprano aria "Come unto Him," Jennens took liberties with this text. In Matthew's Gospel both texts are first-person quotes by Jesus: "Come unto Me" and "My yoke is easy, and my burden is light." Why did Jennens change them to the third person? Was it to maintain similarity of treatment between the two texts? Was it to avoid using a first-person narrative in the rendering of the oratorio for the sake of consistency? And why did Jennens choose to use these words to end *Part the First*?

Handel set the word "easy" into thirteen melismatic iterations, as if he intended to make the messianic suffering coming in *Part the Second* even more dramatic by comparison.

Jennens and Handel have taken great care to complete the first act of the drama in the spirit of the Old Testament prophecies as they were understood: a heroic, conquering, and reigning Messiah. "His yoke is easy" is a jubilant setting compatible with those expectations. Its key of Bb Major, with its affect of aspirations for a better world, will stand in abrupt (and most certainly intended) contrast to the very next words we hear at the beginning of *Part the Second*: "Behold the Lamb of God, that taketh away the sins of the world."

DISCUSSION QUESTIONS

1. Check out the descriptions of affects in chapter 1. While examining each movement, compare the text

with Handel's chosen affect, and then determine if you feel it was the best choice. What affect would you have chosen? Why?

2. *Part the First* concentrates on Israel's understanding of a heroic Messiah. Jennens/Handel inserted prophecies of the birth of Messiah—one brief orchestral Pifa, four recitatives for soprano, and one short chorus—between longer sections emphasizing (a) Messiah as conquering hero, and (b) Messiah as healer. Do you feel this *incarnational* episode was sufficient? What prophetic Scriptures might you have added to augment it?

PART THE SECOND
(Redemption Fulfilled, the Prophecies Reinterpreted)

AT THE BEGINNING OF *Part the Second* the Old Testament prophecies are recast and reinterpreted in hindsight. Those who longed for Messiah envisioned One who would come in power and destroy God's enemies. Death, as stated earlier, was not part of the equation: Messiah would not have to die in order to bring about redemption. Yet here, at the outset of *Part the Second,* we are introduced to many prophecies of a despised, rejected, rebuked, and killed Messiah. He *will* suffer; Messiah *will* die.

The central idea of *Messiah,* unfolded in this second act of the drama, is *redemption through personal suffering,* taken from the prophet Isaiah's writings and the Psalms.

There is no description of the *Passion of Jesus* as we might expect from Bach: no crown of thorns; no carrying the cross; no Golgotha; no crucifixion; no recalling Jesus' words from the cross. In fact, there are no passages from

the New Testament accounts of the suffering and death of Messiah. All is Old Testament prophecy.

Part the Second begins the same way as *Part the First*, with a voice crying in the wilderness. No longer is it a wordless Sinfony painting an instrumental e minor shadow of things to come. No longer is it the tenor's E Major transformational words of comfort. Rather, it is a monumental minor key chorus, with its dotted rhythm's anxiety, expressing with words what was foreshadowed in the wordless Sinfony. The conquering hero of *Part the First* was a scripturally incomplete picture of Messiah. We have moved from the message of comfort in *Part the First* to a heart-rending journey heavy with descriptions of suffering. The recast prophecies will reach their fulfillment in the death and resurrection of Jesus on the last pages of *Part the Second*.

13

SCENE 7: REDEMPTION THROUGH PERSONAL SUFFERING

#22
Chorus
Behold the Lamb of God, that taketh away the sins of the world.
(John 1:29)
Affect: "g minor"
Discontent, Uneasiness, Worry about a Failed Scheme

IN THE FOURTH GOSPEL of the New Testament, John the Baptist spoke these words at the beginning of Jesus' ministry, as Jesus came to be baptized. John was the fulfillment of Isaiah's prophecy, "the voice crying in the wilderness, prepare ye the way of the Lord," as sung by the tenor in the first recitative of *Messiah* (#2). John the Baptist saw Jesus as the Lamb whose one-time sacrifice would cover the sins of humankind. The beginning of Jesus' three-year ministry dates to this moment.

Jennens placed this text at the end of Jesus' three-year ministry, the beginning of his suffering; it is a profound start to the reinterpretation of the Old Testament prophecies.

FIGURE 20

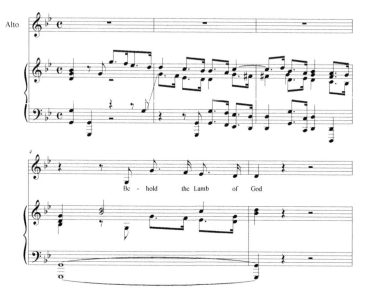

Example 20: Chorus, "Behold the Lamb of God," excerpt, orchestral opening and first statement

Handel has moved from Bb Major optimism for a better world in the concluding chorus of *Part the First* to its relative g minor, the dark side of optimism: discontent, worry, uneasiness. The table-turning bridge between *Part the First* and *Part the Second*—the connection between light and dark—is appropriate and powerful. The dotted rhythms are reminiscent of the foreboding Sinfony. What was unspoken has now been revealed. A new drama, a new beginning, is unfolding.

#23
Alto Aria

He was despised and rejected of men: a man of sorrows, and
acquainted with grief.
(Isa 53:6)
He gave his back to the smiters, and his cheeks to them that
plucked off the hair:
He hid not his face from shame and spitting.
(Isa 1:6)
Affect: "Eb Major," "c minor"
Love, Devotion, Intimate Conversation with God,
Languishing, Longing, Sighing

Handel set these Isaiah texts in *da Capo* form. An opening section is followed by a new musical schematic in the second section, ending with the directive da Capo: go back to the beginning, the "head" of the piece. Often in the repeat, or da Capo, singers demonstrate their vocal prowess through improvised embellishment. In *Messiah*, Handel gave few da capo opportunities for florid embellishments, perhaps to focus on the serious nature of the drama.

In the opening section the text, "He was despised and rejected" is rendered in syllabic declamation: no melismas, no attempts to ornament or color the darkness of the text in spite of the use of a major key. The orchestra joins in the declamation, alternating with the alto in response to the text, and in the process takes on the character of a second soloist.

FIGURE 21

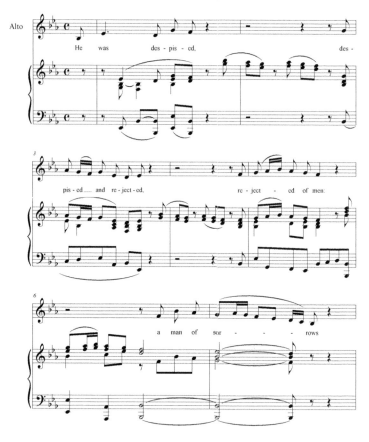

Example 21: Air for Alto, "He Was Despised," excerpt from beginning

One puzzles over the affect of "Love, Devotion, Intimate conversation with God" in this text with its words of rejection. To address this concern, the greater focus, it appears, should be on the phrase "Man of sorrows," stated seven times, rather than on the words "despised, rejected, acquainted with grief." Handel drew our attention to the person, the One who willingly submitted to this torment, the Son of God, Messiah.

FIGURE 22

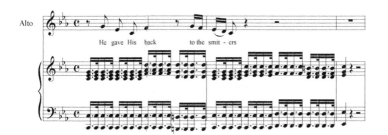

Example 22: Air for Alto, "He Was Despised," excerpt,
"He gave his back to the smiters"

While the first section concentrates on Messiah (perhaps the reason for its major key), the second section concentrates on his tormentors. Handel moves to the relative c minor—the dark side of Eb Major—and incorporates severe anguish into the orchestral palette by use of rapidly stated dotted rhythms that remain relentless throughout. The graphic contrast of light and dark—between a tormented Messiah in the first section and his abusers in the second—is absolutely necessary to the whole narrative.

<div align="center">

#24
Chorus
Surely he hath borne our griefs, and carried our sorrows;
He was wounded for our transgressions; he was bruised for our
iniquities;
the chastisement of our peace was upon Him.
(Isa 53:4–5)
Affect: "f minor"
Deep Depression, Lament, Groans of Misery,
Longing for the Grave

</div>

The fury depicted by dotted rhythms begins in the opening chorus of *Part the Second* (#22), "Behold the Lamb of God," continues in the middle section of the alto aria

(#23) "He gave his back to the smiters," and remains in place at the beginning of this chorus (#24).

FIGURE 23

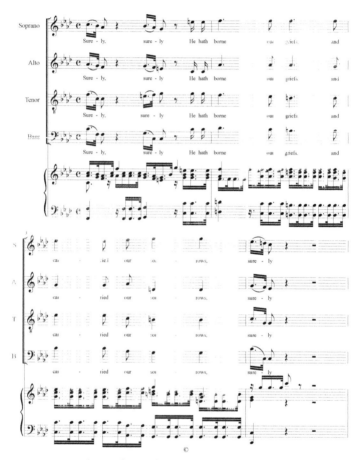

Example 23: Chorus, "Surely He Hath Borne Our Griefs,"
excerpt, dotted rhythms

Thirteen measures into the movement, agitation gives way in both the chorus and orchestra to a more somber

character surrounding the phrase "He was wounded for our transgressions." While the chorus remains in that mood, the orchestra once again picks up the agitated fury so much a part of these opening pages of *Part the Second*.

The focus of *Messiah* has turned its emphasis from his prophesied "incarnation" in *Part the First* toward humanity's "neediness" in *Part the Second*. Notice the texts: "the sins of the world"; "our griefs"; "our sorrows." The affect ("deep depression, lament, groans of misery, longing for the grave") seems to have a dual focus in this chorus: first on Messiah, who suffers on our behalf ("He has borne"), and then on us, the beneficiaries of his suffering ("our griefs . . . our transgressions").

This focus on humanity's great need will remain until the middle of *Part the Second*, where everything will change.

<div align="center">

#25

Chorus

And with his stripes we are healed.

(Isa 53:5)

Affect: "f minor

**Deep Depression, Lament, Groans of Misery,
Longing for the Grave**

</div>

<div align="center">

FIGURE 24

</div>

Soprano — And with His stripes we are heal - ed

*Example 24: Chorus, "And with His Stripes We Are Healed,"
beginning statement*

According to Isaiah's prophecy, Messiah's stripes heal us. As with the previous pages of *Part the Second* we remain the beneficiaries of his suffering. An entire chorus is built on these seven words—"And with his stripes we are healed."

It is the shortest Scripture text in the entire oratorio. Chief among the seven is the word "healed," and the overwhelming good news of it is set in the affect of depression, lament, and misery. He must suffer; it is, according to the Scriptures, our only hope. His stripes provide our healing.

Handel appears consumed by the word "healed," as it occurs thirty-five times in this short chorus. Taken in total, twenty-two of the thirty-five are set in melismas, suggesting the positive, desired, and joyful nature of the word in profound contrast with its minor key setting and f minor affect. One stands out: the melisma in the tenor line lasting sixteen measures!

Handel's treatment of this chorus is remarkable. The affect of the movement—"deep depression, lament, groans of misery, longing for the grave"—is centered on the person Messiah. Yet, in spite of his suffering, the composer overwhelms the listener with joylike melismas on the word "healed"! The overall effect of this overlay of melismas on the lament and misery suggested by the choice of affect is deeply moving. The darkness of his suffering leads to the light of humanity's reconciliation: what better choice of affect than this!

#26

Chorus

All we like sheep have gone astray; we have turned everyone to his own way;
and the Lord hath laid on Him the iniquity of us all.
(Isa 53:6)
Affect: "F Major," "f minor"
Calm
Deep Depression, Lament, Groans of Misery,
Longing for the Grave

Rather than moving to f minor's relative Ab Major, Handel did something unexpected by changing the f minor of the phrase "And with his stripes we are healed" to F

Major (a key associated with sheep and shepherds in *Messiah*). Just as he *transformed* the Sinfony's e minor to the E Major of "Comfort Ye," so here he has transformed the depression, lament, and groans of the previous two choruses into a frolicking caricature of oblivious calm.

FIGURE 25

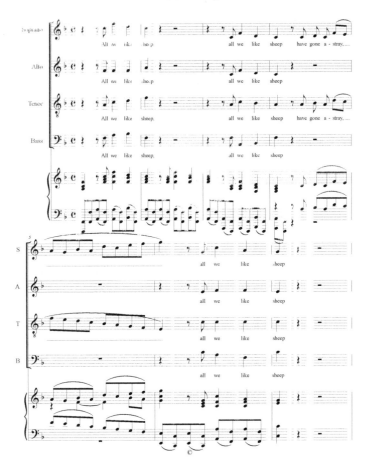

Example 25: Chorus, "All We Like Sheep Have Gone Astray,"
beginning statement

Handel's use of word painting in this chorus presents a clear depiction of waywardness. "All we like sheep" is set in uniform, syllabic homophony each time it occurs. All four vocal lines sing exactly the same words and rhythms in total conformity.

In contrast, the words "have gone astray" are never sung by all four voices simultaneously, and melodic lines veer in different directions, graphically illustrating and defining the character and nature of the text.

FIGURE 26

Example 26: Chorus, "All We Like Sheep Have Gone Astray," excerpt on "turned"

The phrase "We have turned everyone to his own way" appears in single melismatic lines sung by each of the vocal sections with a sense of independence from the others.

FIGURE 27

Example 27: Chorus, "All We Like Sheep Have Gone Astray,"
excerpt on "we have turned" melismas

Eventually each of the four choral parts takes it in turn to shout the words "We have turned" in combative ways as if to convince the others their path is best. Measure after measure, the competition continues until, exhausted, the chorus comes to a momentary halt.

Abruptly the music reverts to the f minor depression of the previous two choruses. The tempo changes to *adagio* (very slow), and the final words of Scripture are sung in a deep lament: "And the Lord hath laid on Him the iniquity of us all." It has been a double transformation—foolishly abandoning f minor lament for F Major calm, then returning to f minor in confession. The returning truth of f minor

recognizes the false premise of the F Major transformational deception. These concluding measures mark one of the greatest contrasts within a movement in the entire oratorio.

FIGURE 28

Example 28: Chorus, "All We Like Sheep Have Gone Astray," excerpt on key change to adagio

#27
Tenor Recitative
All they that see Him laugh Him to scorn;
they shoot out their lips and shake their heads . . .
(Ps 22:7)
Affect: "Bb minor"
A Creature of the Night, Surly, Mocking God and the World

Up to this point the choruses have been primarily the voice of the people of God capping off prophetic words or making confession. Here Jennens seems to have used the prophetic Psalm 22 to depict an unruly crowd at a gruesome crucifixion. The tenor leads the transition. Handel's singular use of Bb minor and its mocking affect in this brief recitative is most appropriate. To further the singularity of Bb minor it must be stated that there is no attending major key (Db Major) using the same key signature in the entire work.

The rhythmic fury Handel used in (#23), "He gave his back to the smiters," returns in this recitative. The mocking frenzy explodes in two brief orchestral outbursts of thirty-second notes, amplifying the anger and fury of the text.

FIGURE 29

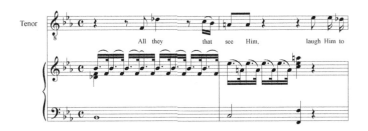

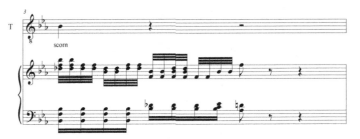

Example 29: Recitative for Tenor, "All They That See Him Laugh Him to Scorn," excerpt on orchestral agitation

Since the beginning of *Part the Second*, Jennens has put together a curious juxtaposition: the sacrificial Lamb of God (#22), humanity's delight in causing his sacrifice (#23), a confession of human need in the two intervening choruses (#24–25), a wayward disregard and another return to confession (#26), then mocking in the tenor recitative (#27). Humanity's fickleness and separation from God seem on display in these six movements.

<div align="center">

#28

Chorus

. . . saying, He trusted in God that He would deliver Him;
let Him deliver Him, if He delight in Him.

(Ps 22:8)

Affect: "c minor"

</div>

Declaration of Love, and at the Same Time the Lament of Unhappy Love.
Languishing, Longing, Sighing of the Love-Sick Soul.

The chorus picks up immediately from the tenor soloist, with the psalmist depicting a crowd gathered at the foot of the cross. The final cadence of the preceding recitative, which began in the surly, mocking key of Bb minor ("a creature of the night, surly, mocking god and the world"), ended in unrelated Eb Major, the key of love, of devotion, of intimate conversation with God. It was a false and brief hope. Handel merely used the concluding Eb Major chord as the gateway to its relative c minor. Compare the two affects: Eb major ("love, devotion, intimate conversation with God"), versus its relative c minor ("lament of unhappy love, languishing, longing, sighing"). The chorus seems conflicted. The crowd shouts a mocking melisma on the word "delight" as if to dare his God to deliver him.

FIGURE 30

Example 30: Chorus, "He Trusted in God," excerpt,
"If he delight" melisma

The voices cascade over each other in a relentless polyphony on the phrase "Let Him deliver Him." No other chorus in *Messiah* abandons the bright side in pursuit of the dark side as starkly and belligerently as does this.

FIGURE 31

Example 31: Chorus, "He Trusted In God," excerpt,
"let Him deliver Him"

They had been looking for their Messiah, and the One who claimed the title was dying. Their declaration of love has turned into a chorus of angry lament through its musical and scriptural depictions of shattered expectations and vengeance. Languishing, longing, and sighing—the affect colors the scene perfectly. Taunting seems coupled with despair; the resulting choral venom disguises a human soul trapped by anguish. Performing this chorus requires a balancing act of interpretive discernment.

#29
Tenor Recitative
Thy rebuke hath broken his heart; he is full of heaviness.
He looked for some to have pity on Him, but there was no man;
neither found he any to comfort Him.
(Ps 69:20)
Affect: Begins in "Ab Major"
The Key of the Grave, of Death

One of the most dramatic settings in the entire *Messiah* is the tenor recitative (#29), "Thy rebuke hath broken his heart." It amplifies and counters the torment meted out by the jeering crowd from the previous chorus. Beginning with the affect of death and the grave in a voice overcome with profound anguish, it descends into an even deeper grief.

Handel's treatment of the text is a musical portrait of brokenness and sorrow. Looking at the accompaniment, one sees a constant harmonic instability incapable of settling in any key. The orchestra moves through fifteen different major and minor chords and five altered chords in a short eighteen measures, ending a full nine key modulations removed from its beginning. One could surmise Handel intended an instrumental picture of torment and anguish.

The melodic line sung by the tenor is completely "undiatonic"; it is unrelated to any major or minor scale. Every chromatic note of the octave is employed—all twelve—with some repeated in their enharmonic renderings. No other movement in *Messiah* unfolds in any similar fashion.

Additionally, Handel used a melodic interval a number of times that was considered outside the parameters of good taste. The interval is called a *tritone*, with three whole-steps between the upper and lower notes. In the Middle Ages the interval was forbidden. "Devil's music" was the definition applied to it for centuries.

Tritones are ambiguous and unstable; they point to no specific tonality or key. They demand a resolution. They can be resolved, but in two different ways, and the resulting key resolutions remain a tritone apart! It occurs twice in the first five notes of the melody.

FIGURE 32

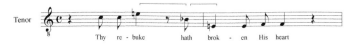

Example 32: Recitative for Tenor, "Thy Rebuke Hath Broken His Heart," excerpt on opening "tritones"

In three other places within the recitative the tritone interval can be found, outlined by the beginning and ending notes of short phrases.

Handel's incorporation of this ambiguous interval is placed at precisely the right spot in the work. We have arrived at the absolute lowest degradation of Messiah, which will lead shortly to his death. All the musical clues from the opening *Sinfony* have merged with all the prophecies of his suffering. They trace a continuing downward line, culminating in this recitative, aria, and the following recitative at an important moment in the oratorio. We have moved from the opening fall in the garden of Eden to the precipice of hell itself. Messiah is on the brink of mortality's consequence.

#30
Tenor Aria
Behold, and see if there be any sorrow like unto his sorrow.
(Lam 1:12)
Affect: "e minor"
Lament, Sighs, Tears
Grief, Mournfulness, Restlessness

What was unspoken and hinted at in the opening instrumental Sinfony, also in e minor, is now defined and given verbal expression here. The melodic instability of the preceding recitative gives way to stability here, though it is the disconcerting stability of our own "lament, sighs, tears,

grief, mournfulness, and restlessness" as we look upon the scene of his abandonment. In the recitative, rebuke and lack of pity from the jeering crowd were predicates to Messiah's heaviness of heart. In this aria, the magnitude of his sorrow is recognized. One is tempted to visualize the conflicted crowd surrounding the crucifixion scene. Some hurl mocking epithets accompanied by acts of derision. Though fewer in number, his friends and family weep. The instability and stability coursing between the tenor's recitative and aria create a fractious dynamic that is reflective of the human condition as seen at Golgotha.

In the recitative Handel described a debilitating rebuke; the response in the aria is a sorrowing sympathy. The aria marks a moment of historical and personal transformation. The turning point of history is soon to be revealed, and humanity is about to be given the possibility of redemption and life.

The aria ends with a B Major chord, the dominant chord leading to either e minor or E Major. Instead of pursuing those obvious and typical resolutions, Handel continues the next recitative with a b minor chord and its transformational affect of *submission* ("patience, calm, awaiting one's fate, submission to divine dispensation").

The oratorio has come to its watershed moment.

14

SCENE 8: PROPHECIES OF DEATH AND RESURRECTION

Turning Point

IN THE MIDDLE OF *Part the Second*, in the exact middle of the tenor's four recitatives and arias, we arrive at a turning point. From here on it is not what humanity does to God that matters, but rather what God does to those who stand against him. The newly reinterpreted prophecies predict a resurrection: (#32) "But thou didst not leave his soul in hell." Resurrection, as we have said previously, had not been associated with Messiah—he wouldn't die and thus would have no need of it. Rather, it was thought that the prophecies referred to the people of Israel who would be brought out of suffering into a new life. All that has changed. Messiah was indeed the figure at the heart of Isaiah's prophecies; we know it now. A new world has dawned, not only

shedding its light on the Scriptures, but more importantly on humanity itself.

#31
Tenor Recitative
He was cut off out of the land of the living:
for the transgression of Thy people was He stricken.
(Isa 53:8)
Affect: "b minor transitional to Eb Major"
Patience, Calm, Awaiting One's Fate, Submission to Divine Dispensation
Joy and Pleasure Not Yet Complete

In Handel's two-hour oratorio, less than fifteen seconds are given to the death of Messiah. Handel has made the death of Messiah transitional in this musical setting, choosing the most appropriate minor to major affects. Beginning with the b minor affect of "fate and submission to divine dispensation," the recitative ends in E Major, hinting at the affect of "joy and pleasure not yet complete": from death to the brink of new life in just five short measures. The text speaks of the grave, but the affect points toward resurrection. The composer has used the power of musical affect itself, independent of the text, to anticipate the future.

FIGURE 33

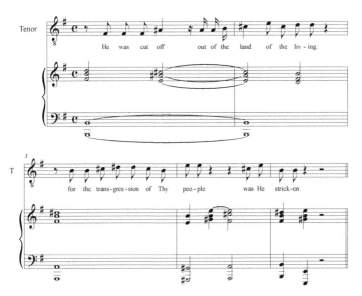

Example 33: Recitative for Tenor, "He Was Cut Off out of the Land of the Living"

<div align="center">

#32

Tenor Aria

But Thou didst not leave his soul in hell;
nor didst Thou suffer Thy Holy One to see corruption.
(Ps 16:10)

Affect: "A Major"

Hope of Seeing One's Beloved Again, Trust in God

</div>

The concluding E Major of the recitative is the dominant doorway to the A Major of this aria: joy, hope, and trust in God are linked.

No melismas are used; looking closely at the text, one cannot find a word that would be suitable for that treatment. Word painting is subtle. The long-ascending diatonic

line "nor didst Thou suffer Thy Holy One to see corruption" hints at the abandonment of hell (from the grave to the skies). The text prophesies resurrection clearly, augmented by the affect Handel employed ("hope of seeing one's beloved again, trust in God"). Messiah will be seen again; God can be trusted.

Again, Handel has used the key symbolically, not only for its affect, but also for its link to the only other use of A Major in the oratorio: chorus (#4) "And the glory of the Lord shall be revealed." In that first instance the virgin birth was anticipated. Here, in the second, the risen Lord is revealed. Both embrace miraculous appearances: incarnation and resurrection, the beginning and ending of Messiah's existence in human flesh.

15

SCENE 9: FROM RESURRECTION TO ASCENSION

#33
Chorus
Lift up your heads, O ye gates; and be ye lift up, ye everlasting doors;
and the King of glory shall come in. Who is the King of glory?
The Lord strong and mighty, the Lord mighty in battle.
Who is the King of glory? The Lord of Hosts, He is the King of glory.
(Ps 24:7–10)
Affect: "F Major"
Calm

PSALM 24 IS NORMALLY associated with Jesus' entry into Jerusalem on Palm Sunday. Jennens carefully placed it here to express jubilation over the return of Messiah to the land of the living following his death as a result of his resurrection: entry into a *new Jerusalem*, so to speak.

Handel divided this chorus into two groups: women's voices and men's voices. The women state the invitation

to welcome the King of glory. The men ask, "Who is this King of glory?" The women respond: "The Lord strong and mighty, the Lord mighty in battle. The Lord of hosts, He is the King of glory." Melismas on "glory" dominate the singing.

Previously the affect of F Major calm was used to portray the Good Shepherd (#20), "He shall feed his flock like a shepherd," and the wayward sheep (#26), "All we like sheep have gone astray." At this point, Jesus, the Good Shepherd, has returned from the grave as the King of glory and Messiah. There will be no more need for F Major calm in the face of either suffering or death; hope has replaced it. F Major will not return again.

<div align="center">

#34
Tenor Recitative
Unto which of the angels said He at any time,
Thou art my Son, this day have I begotten Thee?
(Heb 1:5)
Affect: "A Major"
Hope of Seeing One's Beloved Again, Trust in God

</div>

Jennens inserted a curious text at this juncture. Taken by itself the question seems lacking in context and specificity. In order to be fully understood, the four preceding verses from Hebrews 1 need to be inserted here:

> *In the past God spoke to our forefathers through the prophets at many times and in various ways, but in these last days he has spoken to us by his Son, whom he appointed heir of all things, and through Whom he made the universe. The Son is the radiance of God's glory and the exact representation of his being, sustaining all things by his powerful word. After he had provided purification for sins, He sat down at the right hand of the Majesty in heaven. So he became as much superior to*

the angels as the name he has inherited is superior to theirs. (Heb 1:1–4 NIV)

Another passage, from the Epistle to the Philippians, amplifies the same sentiment:

> *And being found in human form, He humbled Himself by becoming obedient to the point of death, even death on a cross. Therefore God has highly exalted Him and bestowed on Him the name that is above every name, so that at the name of Jesus every knee should bow, in heaven and on earth and under the earth, and every tongue confess that Jesus Christ is Lord.* (2:8–11)

These New Testament passages declare there is only one Son of the Father, equal to the Father, who cancelled sin through his sacrifice. There is only One who sits at the Father's right hand: the uncreated One who with his Father brought everything into existence. Jesus is the prophesied Messiah. As the Lord of glory, raised from the dead, he thereby is granted power over all the forces of evil as well as superiority over all the angels of heaven.

Handel has used the same A Major affect as in (#4), "And the glory of the Lord shall be revealed," and (#32), "But Thou didst not leave his soul in hell," confirming both the anticipation of Messiah and his validating deliverance from the grave. In this recitative (#34), God confirms it: "Thou art my Son."

Approaching this recitative and the following chorus from the viewpoint of *resurrection certainty and Deified superiority* is the only way to understand Jennens' use of them in his *Spiritual Collection*. The risen One's authority over both the creatures of earth and the angels of heaven stands at the heart of their inclusion.

#35
Chorus
Let all the angels of God worship Him.
(Heb 1:6)
Affect: "D Major"
Triumph, War Cries, Victory, Hallelujahs, Rejoicing

In light of the victory of Messiah over death, and in response to his superiority over all creation, this short verse is the proper response to the tenor recitative that precedes it (#34), "Thou art my Son." Using the affect of D Major underscores the importance of this short chorus, as it is the overwhelming key/affect in the entire oratorio. Notice again the other instances:

Behold, a virgin shall conceive and bear a Son
O Thou that tellest good tidings to Zion
And suddenly there was with the angels a multitude of the heavenly host praising God
Glory to God
Hallelujah Chorus
Behold I tell you a mystery, we shall not all sleep
The trumpet shall sound
Worthy is the Lamb that was slain
Blessing, glory, honor, and strength
Amen

#36
Bass Aria
Thou art gone up on high,
Thou hast led captivity captive, and received gifts for men;
yea, even for Thine enemies, that the Lord God might dwell among them.
(Ps 68:18)
Affect: "d minor"
Hypochondriacal and Hysterical (A Curious Definition)

Jennens applied Psalm 68 to the ascension of Jesus following his resurrection. While ascension into heaven is part of the complete New Testament messianic narrative, Jennens may have had a deeper motive in mind: the possibility of ascension for his entire creation. To fully understand Psalm 68 in *Messiah* one must read the elaboration given to it in Eph 4:8–12:

> *When he ascended on high, he led captive a host of captives, and he gave gifts to men. Now this expression, "He ascended," what does it mean except that he also had descended into the lower parts of the earth: he who descended is himself also he who ascended far above all the heavens, that he might fill all things.*

Biblical scholarship describes the word "descended" as a reference to the incarnation. "Ascended" is a reference to his resurrection *and* his rise to heaven. Having been temporarily captured by death he now, through the resurrection, proclaims victory over it. The phrase "Thou hast led captivity captive" points to humanity being freed from the bondage and captivity of death. It brings to mind Eastern Orthodox icons depicting Jesus at the moment of his resurrection—the grave is opened, and the resurrected Christ leaps upward using the skull of death as his launching pad. With one hand, he pulls Adam from the grave, with the other, Eve. Those in death's captivity are now captive to the resurrected One.

Handel's use of the d minor affect appropriately links this aria to the previous instances of its use: the bass recitative (#5), "Thus saith the Lord of hosts, yet once a little while and I will shake the heavens," and the aria that follows (#6), "But who may abide the day of his coming?" Both reference the overwhelming power of the coming Messiah, as

does this passage. Also interesting is that all three instances of d minor are set for the bass soloist.

Handel uses short melismas on the words "enemies" and "dwell," as if to conflate and draw a link between them. According to the Scriptures, no one is excluded from the possibility of eternal life, stating in 1 Pet 3:18–20 that Jesus died for the just and the unjust; God's enemies are not beyond hope, not yet. That might explain why the text "That God might dwell among them" is the most prominently used phrase in the aria.

FIGURE 34

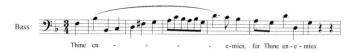

Example 34: Air for Bass, "Thou Art Gone Up on High," excerpt, "Thine enemies"

FIGURE 35

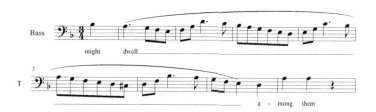

Example 35: Air for Bass, "Thou Art Gone Up on High," excerpt, "might dwell among them" melisma

While in its simplest rendering the aria's placement in the oratorio appears to be as a sign of Jesus' ascension, the musical emphasis is centered on humanity's resurrection,

freedom from death, and future reconciliation. The aria is pregnant with significance; it unpacks both the power and vast reach of Messiah's resurrection, extending hope even to his enemies.

16

SCENE 10:

THE GOSPEL IS PREACHED

#37
Chorus
The Lord gave the word: great was the company of the preachers.
(Ps 68:11)
Affect: "Bb Major"
Aspirations for a Better World

WHAT A STENTORIAN BEGINNING! The word from the Lord in the Gospels was, "Go and make all nations my disciples; bring the message of forgiveness to all nations" (Matt 28:19–20). His followers obeyed his command. Both history and tradition state that the gospel was preached as far west as Spain, as far south as Ethiopia, as far north as the border of Russia, and as far east as India: all this by men in sandals traveling on foot and in sailboats. As the text describes, "Great was the company of the preachers." As the affect describes, the word proclaims aspirations for a better world.

Handel again used melisma effectively, applying it to the word "company" again and again throughout the chorus. Setting the melismas in polyphony adds weight and graphic eloquence not only to their joyful, life-changing message, but also to the numbers of preachers and their diverse mission.

What seems apparent here and in the next two movements is that Jennens wanted to parallel the New Testament book the Acts of the Apostles. In it the community of believers took the message of the risen Messiah to the uttermost parts of the earth. "Aspirations for a better world" were being given "legs." This chorus marks the beginning of the apostles' journeys.

#38
Soprano Aria
How beautiful are the feet of them that preach the gospel of peace,
and bring glad tidings of good things.
(Rom 10:15)
Affect: "g minor"
Discontent, Uneasiness, Worry about a Failed Scheme

The composer moved from the previous chorus in Bb Major to its relative g minor, suggesting their direct relationship. It also suggests that the proclamation of the gospel, though holding prospects for a better world, has a threatening dark side.

Handel's use of a 12/8 meter recalls the "Pastoral Sinfony" or "Pifa" and the alto/soprano arias (#20), "He shall feed his flock like a shepherd," and "Come unto Him all ye that labor and are heavy laden." There is a difference between this aria and the previous movements in the same meter; all the others were in major keys (C, F, and Bb) representing innocence, simplicity, calm, and aspirations for a better world. "How beautiful are the feet" deceptively links

a gentle, pastoral meter with an affect quite the opposite, clothed in a minor key. A positive message for the world is clothed in discontent, uneasiness, and worry. Why?

History confirms that all the apostles but one (John) died as martyrs across the Greco-Roman world. Their message of aspirations for a better world carried great risks as evidenced by their martyrdoms.

Jennens' historical understanding, his understanding of Scripture itself, and Handel's carefully rendered sense of musical thought and affect are applied to this text: a world-changing message cloaked in a life-threatening environment. Jennens and Handel must have felt this deeply and personally, as a similar battle between Christianity and the Enlightenment was being waged in their own day.

#39
Chorus
Their sound is gone out into all lands,
and their words unto the ends of the world.
(Rom 10:18)
Affect: "Eb Major"
Love, Devotion, Intimate Conversation with God

On its surface this verse seems redundant. The previous two movements (#37–38) tell the story of being called to mission and responding to the call. Handel's *Messiah* would seem not to be diminished if Rom 10:18 had been excluded from Jennens' *Scripture Collection*. He must have had a good reason for including it.

According to the New Testament each apostle traveled alone throughout the known world. Handel demonstrates that individuality in this polyphonic movement. It musically dramatizes the truth of the gospel being taken in various directions throughout the entire Greco-Roman world: the same message, different journeys—a polyphonic mission so to speak.

Essentially syllabic in character, there are nonetheless three words in this chorus that could lend themselves to melismatic settings: "sound," "words," and "world."

Of these, Handel chose "world," which is difficult to sing beautifully because of the "r-l-d" ending of the single syllable word. Singers struggle with the unmusical letter "r," especially when it comes at the end of a word. The "l" and "d" of "world" further complicate the task.

Handel could have chosen "sound" as the preferred melismatic choice for several reasons. First, it represents the message being brought to the world by the apostles. Second, it sings well. To call attention to "sound" (or "word," also difficult to sing because of the "r-d" ending) would emphasize the *message of reconciliation.* However, that has been covered throughout *Part the Second* as it recounts the suffering, death, and resurrection of Messiah.

Look back at the opening chorus of *Part the Second* (#22), "Behold the Lamb of God that taketh away the sins of the world." It expressed "the world's need and the Provider." Look ahead to the last chorus of *Part the Second* (#44), "The kingdom of this world is become the kingdom of our Lord and of his Christ." It will express the "resurrection outcome." What hasn't been emphasized is the extent or coverage of the message. Romans 10:18, "unto the ends of the world," expresses the inclusive geography desired by the risen Lord. "World" is the ideal summation.

"World" appears only in these three choruses; taken together they form yet another synopsis in *Messiah*: (#22) need and Provider; (#39) mission; and (#44) kingdom victory. Romans 10:18 is essential. Redundancy is overcome. "World" is the perfect choice for a melisma: musically challenged but programmatically imperative.

The Eb Major affect is also perfect: "love, devotion, intimate conversation with God." The apostles not only

obeyed the command to propagate the gospel message; they took it far and wide. It cost them their lives; all eleven died alone as martyrs throughout the known world. Love and devotion came at a price they willingly paid.

Immediately upon the "word" being proclaimed to the "world" in this chorus, the nations rise up against the message; earthly kings rise up against Messiah. The people revolt. The bearers of the gospel will die in the onslaught.

17

SCENE 11: THE RESURRECTED MESSIAH DEFEATS THE ENEMIES OF GOD

#40
Bass Aria
Why do the nations so furiously rage together?
Why do the people imagine a vain thing?
The kings of the earth rise up, and the rulers take counsel
together
against the Lord and against his Anointed.
(Ps 2:1–2)
Affect: "C Major"
Purity, Innocence, Simplicity, Naïveté

THE PRECEDING NINE MOVEMENTS of *Messiah* focused on texts representing the death and resurrection of God's son. They continued through his ascension to the throne of heaven where he was crowned with the Name above all names. In his Name the gospel began to be preached.

In this aria a battle rages. Why now? Isn't it too late for the forces aligned against Messiah to rebel? Hasn't his resurrection solidified his victory over sin and death? The accompaniment's fury is relentless and inhabits a long orchestra introduction accomplished by a huge melodic range in the violins.

FIGURE 36

Example 36: Air for Bass, "Why Do the Nations So Furiously Rage Together," excerpt, orchestral "fury"

The bass melodic line also covers a wide expanse marked by leaps and melismas, taxing the soloist perhaps more than any other aria in the oratorio.

FIGURE 37

Example 37: Air for Bass, "Why Do the Nations So Furiously Rage Together," excerpt, melisma on "rage"

Psalm 2 is a royal coronation psalm. Israel's belief was that God chose new kings. Throughout the Hebrew Scriptures the coronation of a new king was the time other kings chose to revolt; therefore, to conspire against a king was to conspire against God. In his day, Jennens considered Deism and the Enlightenment enemies of orthodox Christianity. That may partially explain Jennens' inclusion of Ps 2 at this point in the story. Christian redemption was being countered by the forces aligned against it.

There is nothing pure or innocent in this raging chorus, as the affect might suggest. The only movements in C Major to this point have been the "Pastoral Symphony" (#13), preparing for the birth of Messiah, and its following recitative (#14), introducing the simple shepherds.

The preaching of the gospel preceded this aria with its Eb Major good news of "love, devotion, and intimate conversation with God." What compositional choice did Handel have? Moving to Eb Major's relative c minor would have falsely pictured God's enemies as languishing and lamenting their unhappy love. Such an affect would have been counter to the fury released in this aria.

Is there an answer to this dilemma of affect? Those jeering voices railing against Messiah prior to his crucifixion are the very nations now furiously raging against the risen Lord. The text states, "Why do the people imagine a vain thing," suggesting there is no possibility of success; it is unimaginable. Examine the key change in the middle of the aria leading into the text, "The kings of the earth rise up, and the rulers take counsel together against the Lord and his anointed." Handel moves to C Major's relative a minor, the dark side. Did he choose C Major for the purpose of setting up the psychological darkness of a minor?

The rage and fury in this aria and the final attempt to thwart Messiah in the following chorus bring God's enemies to the brink of exhaustion. The highest point of their

rebellion will be matched by the lowest depths of their futility and defeat—we have reached the "endgame."

#41
Chorus

Let us break their bonds asunder, and cast away their yokes from us.
(Ps 2:3)
Affect: "C Major"
Purity, Innocence, Simplicity, Naïveté

The opening fury of the preceding bass aria returns, railing against the Lord in a very extensive musical onslaught. It is a naïve exercise in futility. God's followers know it, but his enemies do not; they harbor false hope. This is their final shout, their "last hurrah"; such oppositional voices will remain silent for the duration of the oratorio.

#42 & 43
Tenor Recitative and Aria

He that dwelleth in heaven shall laugh them to scorn; the Lord shall have them in derision.
(Ps 2:4)
Thou shalt break them with a rod of iron; Thou shalt dash them in pieces like a potter's vessel.
(Ps 2:9)
Affect: "A Major"
Transitional to "a minor"

God's ultimate response to the preceding chorus is exposed. A four-measure recitative introduces the aria where, once again, fury will dominate the action; not the raging fury of those opposed to God, but rather God's fury poured out on his enemies. The orchestral bass line inserts *marcato* chords intermittently, countering the upper strings' rapid activity, leaping back and forth between the two tonal registers in a litany of instrumental aggression.

FIGURE 38

Example 38: Air for Tenor, "Thou Shalt Break Them,"
excerpt, orchestral "fury"

The word painting technique on the words "break them," "dash them," and "pieces" is clearly intended; each has two syllables that are never sung with two adjacent musical pitches. They are always disjointed, just as the words themselves suggest.

The tenor's melodic line expresses the same fury of register expansion as the orchestra. Of particular interest and importance is the melisma on "potter's vessel."

The use of a minor links the Lord's defeat of his enemies most powerfully to the futility expressed in the a minor conclusion of the bass aria (#40), "The kings of the earth rise up." The textual union and byplay of these two movements is obvious, and the affect is perfect.

There could be no more powerful setup for the explosive response that follows.

18

SCENE 12: IN RESPONSE, THE BELIEVERS SING

#44
Chorus

HALLELUJAH! For the Lord God omnipotent reigneth.
The kingdom of this world is become the kingdom of our Lord,
and of his Christ
and he shall reign for ever and ever,
KING OF KINGS, AND LORD OF LORDS. HALLELUJAH!
(Rev 19:6; 11:15; 19:16)
Affect: "D Major"
Triumph, War Cries, Victory, Hallelujahs, Rejoicing

WHILE WRITING THE "HALLELUJAH" Chorus," Handel's servant is said to have discovered him with tears in his eyes. According to his report the composer exclaimed, "I did think I saw all Heaven before me, and the great God Himself!"[1]

1. *The Academy*, Supplement of July 15, 1905, Volume LXVIII, in a section on music, 478.

The "Hallelujah Chorus" is iconic. It is the single movement in *Messiah* that first comes to mind when people talk about Handel. It needs no elaborate treatment here, though a few thoughts are warranted. First, the composer beautifully combined both the homophonic and polyphonic styles typical of his compositional technique we discussed in (#12), "For unto us a Child is born." Second, there is no need for melismatic treatment of the text. Melismas would get in the way of its dramatic proclamation. Beauty for its own sake has been set aside in favor of power and authority.

Jennens brings the apostle John's apocalyptic scenario from Revelation into play here at the end of *Part the Second*. Why here? Why now? Passages from Revelation will return to conclude the oratorio, so at first glance the passage seems out of place in this location.

Messiah's resurrection ushers in a new era. Death has been defeated in this act of God on behalf of his Son. In other words, humanity already lives in a time fulfilled; the "kingdom of our Lord and of his Christ" is already established via his resurrection. All English translations of Revelation 11:15 read, "has become" or "is become," not "will become." The kingdom is both a present reality *and* a future hope.

One single moment in the chorus deserves attention. In the middle of the movement the phrase "the kingdom of this world" (reflecting on the entire work up to this point) makes its only appearance, set low in all four voices with the dynamic marking piano. The next phrase, "is become," remains in the lower vocal registers, though the dynamic marking is increased to mezzo-forte. Then all the voices leap upward—the altos up five notes, the tenors up six, the basses up eight, and the sopranos up ten—exploding with a forte exclamation, "the kingdom of our Lord and of his Christ." It is a magnificent moment, the only instance

of word painting in this chorus. The two kingdoms—this world and the kingdom of God—though separated by a vast (vocal) distance, are fused and made one. *Fallen creation* has been reconciled with a *new creation*. The entire activity of God and his Son—creation, fall, incarnation, suffering, death, resurrection, and ascension—has been crystallized in this singular and potent phrase: "The kingdom of this world is become the kingdom of our Lord and of his Christ."

FIGURE 39

Example 39: Chorus, "Hallelujah," excerpt,
"The kingdom of this world . . ."

The trumpet, used frequently in the Baroque as a symbol of heaven, serves that purpose here. Baroque trumpets were not the trumpets we know today. They were more

like large bugles without valves. The extensive tubing made possible two distinct playing ranges. The lower, *Principale*, was confined to the lower "harmonics" or "overtones" we associate with a modern-day bugle. Think of bugle calls or "Taps," where the notes, if sounded together, would create a major chord, not a diatonic scale pattern. The upper register was called *Clarino*. The higher up the chain of "harmonics" or "overtones" one progresses, the closer the pitches are to each other, resulting in the instrument being able to play adjacent diatonic notes of the scale. All this is accomplished by the tension of the player's lips, or *embouchure*. To accomplish the musical demands on a valveless instrument makes these trumpet passages even more impressive.

Finally, it is important to realize that the "Hallelujah Chorus" is a paean of praise in response to the defeat of God's enemies. It follows the previous movements where God overpowered and destroyed those who stood against his Messiah. It is not a hymn of thanksgiving for the birth of Messiah. It is a hymn of "triumph, war cries, victory, hallelujahs, and rejoicing." As such, it is the only response capable of bringing comfort to those who suffered under persecution wrought by the enemies that stood against the kingdom of our Lord.

DISCUSSION QUESTIONS

1. As in the questions for *Part the First*, check out the descriptions of affects in chapter 1. While examining each movement, compare the text with Handel's chosen affect, and then determine if you feel it was the best choice. What affect would you have chosen? Why?

2. Tucked in between long episodes concentrating on a Suffering Messiah and a Conquering Messiah, Jennens inserted one brief recitative on Messiah's death and resurrection. This is parallel to his brief incarnational episode in *Part the First*. What Scriptures might you have added to augment it?

PART THE THIRD

(The Promise to All Believers: New Testament Hope)

ALREADY, BUT NOT YET.

The "Hallelujah Chorus" almost brings *Messiah* to a premature end. Clearly, the former development has run its course. A new development is on the horizon.

In *Parts the First* and *Second* prophecies of redemption by Messiah were portrayed in changing sections, in scenes of great intensity often thrown into relief by contrasts: the opposition of dark and bright, shadow and light, the battle between life and death, and the impotence of humanity versus the power of the Almighty. The two parts seemed unusually dramatic simply by virtue of their continual contrasting.

In *Part the Third* the dramatic development is past. Now that both the possibility and foundation of redemption have been established, there is no more tension to be eased. This section confines itself to two things: homage to

the triumphant Savior for his overthrow of death, and our participation in his resurrection. These are the only proper conclusions to what has gone before. Jennens' *Scripture Collection* would only be an exercise in futility if it stopped short of revealing what Messiah's death and resurrection provide for humanity. Ending with the "Hallelujah Chorus" would have made *Messiah* an account of glorious history, but that wouldn't be enough. *Part the Third* is about our eternity.

Part the Third becomes personalized; hope is granted to its recipients. When God raised his Son from the dead— Jesus as the *firstfruits*—it was a promise that what God did for his Son was only the beginning.

Already, but not yet.

Part the Third announces prophecies of a different nature, taken from a different source—1 Cor 15, the apostle Paul's great resurrection chapter. The New Testament picks up where the Old Testament left off. Jennens has changed the nature of an oratorio, formerly based upon Old Testament stories involving casts of characters and dialogue. While embracing the Old Testament prophecies, he has proceeded to their reinterpretation and fulfillment from the pages of the New Testament.

The focus here again is on us. It is not our "neediness" that is addressed, as in the first choruses of *Part the Second*. The new object of attention is our "promise," directly related to the resurrection of Messiah: our death, like his, has also been defeated. We, the *latter fruit*, will be raised and gathered around the throne of the *Firstfruit* Messiah singing, "Worthy is the Lamb Who was slain."

Already, but not yet!

19

SCENE 13: HOMAGE TO THE TRIUMPHANT SAVIOR

#45
Soprano Air
I know that my Redeemer liveth,
and that he shall stand at the latter day upon the earth;
and though worms destroy this body, yet in my flesh shall I see God.
(Job 19:25–26)
For now is Christ risen from the dead, the first-fruits of them
that sleep.
(1 Cor 15:20)
Affect: "E Major"
Noisy Shouts of Joy, Pleasure, Not Yet Complete Full
Delight

JENNENS USED THE OLD Testament book of Job as a pro-
phetic reference to Christ the Redeemer in the New Tes-
tament. In Hebrew a "redeemer" is one who "vindicates"
or delivers people from *affliction*. Job was falsely accused.

He trusted in his God to prove his innocence, and he was "redeemed" or "vindicated."

The Christian "Redeemer" is someone who delivers humanity from *sin*. Messiah's death accomplished that deliverance. He was then "vindicated" by his Father in the resurrection. His death and resurrection together link Job's prophecy in the Old Testament to its fulfillment in the New Testament. Notice that Jennens included both Testaments in this single soprano aria.

There is a sweetness in Handel's melodic setting of this text. Beauty has overwhelmed tension; confidence has removed anxiety. He has chosen the perfect way to begin *Part the Third,* with its emphasis on future hope. One can easily apply the affect of E Major to this text, particularly the "not yet complete full delight" as it pertains to the concept of firstfruits: Messiah as the firstfruit from the dead, and those who embrace him as the latter fruit. In the two-part construction of the aria, the first half states with absolute certainty the resurrection of the Redeemer himself: "I know that my Redeemer liveth." In the second half, the author of Job expresses confidence in our own bodily resurrection: "Yet in my flesh shall I see God."

The aria then turns back on itself, suggesting the firstfruit resurrection of Messiah is just the beginning; latter fruit is promised. Perhaps the most striking confidence in this promise occurs on the last page of the soprano aria, where the New Testament phrase "For now is Christ risen from the dead" is stated in a dramatic, upward scale pattern covering more than an octave, peaking on the word "risen."

FIGURE 40

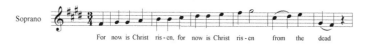

Example 40: Air for Soprano, "I Know That My Redeemer Liveth," excerpt, "for now is Christ risen . . ."

Another point confirming the intentional use of the E Major affect is that it was used only once previously. In the opening tenor recitative (#2) and aria (#3) from *Part the First*, the tenor introduced the first words of Handel's *Messiah*: "Comfort ye . . ." and "Ev'ry valley shall be exalted and ev'ry mountain and hill made low; the crooked straight and the rough places plain." That is precisely what Messiah, the risen One, the firstfruit, has accomplished as stated in this aria. It is a perfect linkage.

#46
Chorus

Since by man came death, by man came also the resurrection of the dead.
For as in Adam all die, even so in Christ shall all be made alive.
(1 Cor 15:21)
Affect: "a minor" to "C Major"; "g minor" to "d minor" to "a minor"

It was considered confusing to apply multiple affects in a single movement, yet that is what Handel has done in this chorus. Why, and to what purpose? How did the composer overcome the possible confusion and convert the potential hazards into a grand statement of faith? The theological pregnancy of this short chorus deserves attention.

Examine the various affects traversed in this short chorus. The first of the four phrases—"Since by man came death"—is set in the same key (a minor) as the tenor aria

(#43), "Thou shalt break them with a rod of iron." Death and the defeat of the enemies of God are thus linked.

The second phrase is in C Major, the transformational bright side of a minor: "By man came also the resurrection of the dead." It states in the affect of purity and innocence that another man, Messiah, will bring resurrection, the antidote to death. C Major also looks back to the incarnation, the virgin birth, and the calm of the shepherds' field in the Pastoral Sinfony and following recitatives (#13–16).

Phrase three—"For as in Adam all die"—is set in the g minor affect of "discontent, uneasiness, worry about a failed scheme." Adam's failed scheme for knowledge equal to that of God cast humanity into the great peril of mortality.

The final phrase—"Even so in Christ shall all be made alive"—returns to a minor. It appears Handel intended a linkage with (#43), "Thou shalt break them with a rod of iron," setting the power of Christ's resurrection against the impotence of human scheming by ending in the same key. The *Second Adam* redeems humanity from the penalty brought about by the sin of the *first Adam*: a direct substitute. Both the text and the affect become transformational.

Handel used a variety of contrasts in the two halves of the chorus. In each half the conflict is between man and Christ. The first phrases of each half—"Since by man came death" and "For as in Adam all die"—are marked *Grave* (slowly deliberate) and *Piano*, and sung without accompaniment.

The second phrases of each half—"By man came also the resurrection of the dead" and "Even so in Christ shall all be made alive"—are marked *Allegro* (fast) and *Forte*. Orchestral color returns.

Looking back, if we isolate two keys used by Handel in *Messiah*—C Major and its relative a minor—another contrast emerges.

C Major first appeared in the "Pastoral Symphony" (#13) and the soprano recitative that followed, "There were shepherds abiding in the fields" (#14). The stage was set for the miraculous virgin birth that would result in the redemption of the world. The last use of C Major occurred in the second phrase of this chorus with the words, "By Man came also the resurrection of the dead." What was promised in the "Pastoral Symphony" was fulfilled in the resurrection. In between these two points, men rebel using the same C Major affect: in "Why do the nations so furiously rage together" (#40), and "Let us break their bonds asunder" (#41). C Major was hijacked in a failed effort to destroy the Lord's anointed. Handel let us know their efforts would fail by moving their efforts back to the dark side, a minor, in "The kings of the earth rise up." God's fury against those rebelling kings is unleashed in the same a minor: "Thou shalt break them with a rod of iron" (#43).

In this remarkable chorus we see a microcosm of the entire work—*Messiah* in a nutshell. It looks back toward the beginning of disobedience, while also looking ahead to the final consummation and the end of history itself. The entire oratorio has been distilled into its pure essence. Sin and death have been conquered through the sacrifice and resurrection of Messiah.

20

SCENE 14:

RESURRECTION HOPE

#47
Bass Recitative
Behold, I tell you a mystery; we shall not all sleep
but we shall all be changed in a moment, in the twinkling
of an eye,
at the last trumpet.
(1 Cor 15:51–52)
Affect: "D Major"
Triumph, War Cries, Victory, Hallelujahs, and Rejoicing

THE WORD "BEHOLD" OCCURS five times in *Messiah*. Three are in dark side minor keys: (#10) "For behold, darkness shall cover the earth"; (#22) "Behold the Lamb of God Who takes away the sins of the world"; and (#30) "Behold, and see if there be any sorrow like unto his sorrow."

The other two stand out from the rest. The alto recitative (#8), "Behold! A virgin shall conceive," is the first time D Major is used. The soloist sings the first word, beginning

on the note D, moving on the second syllable a major third upward to F#. Handel begins this bass aria in the very same way: key of D Major, with the word "behold" cast in the same D–F# interval. These two recitatives appear to be linked (they are the only two of the five that begin with the D–F# interval).

FIGURE 41

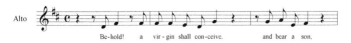

Example 41: Recitative for Alto, "Behold! A Virgin Shall Conceive,"
excerpt, opening statement

FIGURE 42

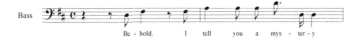

Example 42: Recitative for Bass, "Behold, I Tell You a Mystery,"
excerpt, opening statement

Both recitatives' texts are alike in that they reveal miraculous events: in the first instance, the miracle of the virgin birth of Messiah—"heaven to earth"; in the second, the miracle of being raised from the dead—"earth to heaven." As with the preceding chorus (#46), "Since by man came death," these six- and eight-measure recitatives also reveal the beginning and the end, the promise and its fulfillment.

#48
Bass Aria with Trumpet

The trumpet shall sound, and the dead shall be raised incorruptible,
and we shall be changed.
For this corruptible must put on incorruption, and this mortal must put on immortality.

(1 Cor 15:52–53)
Affect: "D Major"
Triumph, War Cries, Victory, Hallelujahs, and Rejoicing

This is the only major instrumental solo in the entire oratorio. Understanding the symbolic use of the trumpet in religious works during the Baroque period, one could easily be drawn toward the promise of heaven even without the aria's text. The trumpet leads with a long introduction and ends the aria with a long reprise, forming what could be considered an example of instrumental word painting.

Handel has again employed the da Capo aria format, with two contrasting sections followed by a return to the first section.

FIGURE 43

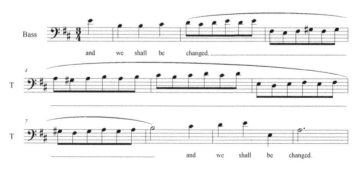

Example 43: Air for Bass, "The Trumpet Shall Sound," excerpt, "and we shall be changed"

In the "A section" interchange between the bass and trumpet soloists, one is captivated by Handel's use of melisma; it occurs six times on the word "changed." The concept of transformation hinted at from the very beginning of *Messiah* and continuing throughout has now become complete in this final promise.

In the "B section" the trumpet is silent. Emphasis centers on the words "Put on" (one melisma), and "immortality" (two melismas). Death, previously having given way to resurrection, is now joined by mortality giving way to immortality. We have achieved the ultimate transformation.

The trumpet solo, "Behold, I tell you a mystery," and "The trumpet shall sound" all begin with the D Major arpeggio, D–F#–A–D. The key of D Major has been at the center of the entire composition since (#8), "Behold a virgin shall conceive," constantly hinting at the future "triumph, war cries, victory, hallelujahs, and rejoicing" that form the basis for hope. Now the prophetic mystery which began with the first chords of *Messiah* gives way to the actual trumpet call that interrupts history, signaling the final triumph of life over death. Though different rhythms are used, the entire musical passage of the recitative and aria manifests an incredible power of persuasion through the extensive fleshing out of the D Major triad in a complete D–F#–A–D arpeggio. This is the first such complete rendering of the D Major chord in the entire oratorio. Its fullness is revealed—here—at the end of the age. The clouds have parted. Heaven is revealed.

FIGURE 44

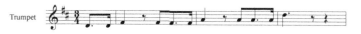

Example 44: Air for Bass, "The Trumpet Shall Sound," excerpt, trumpet solo D Major arpeggio

FIGURE 45

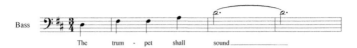

*Example 45: Air for Bass, "The Trumpet Shall Sound," excerpt, bass
solo D Major arpeggio*

21

SCENE 15: THE CONCLUSION OF THE APOSTLE PAUL'S WORDS TO CORINTH

THE FOUR MOVEMENTS IN this scene are often omitted from abbreviated performances of *Messiah*. Coming after the glorious bass aria (#48), "The trumpet shall sound," they seem anticlimactic by comparison. Jennens must have felt additional confirmations of eternal life and the defeat of death were warranted in order to bring the apostle Paul's resurrection chapter to a proper conclusion.

#49 & 50
Alto Recitative and Alto/Tenor Duet
Then shall be brought to pass the saying that is written:
Death is swallowed up in victory.
(1 Cor 15:54)
Affect: "Bb Major"
Aspirations for a Better World
O death, where is thy sting? O grave, where is thy victory?
The sting of death is sin, and the strength of sin is the law.
(1 Cor 15:55–56)

Affect: "Eb Major"
Love, Devotion, Intimate Conversation with God

Swallowed up! This graphic phrase in the Bb Major recitative marks the end of death, with "aspirations for a better world" on the brink of realization. It serves as a succinct prelude to the gleefully mocking tone that permeates the following duet, where the alto and tenor soloists tumble over each other in their interchange. The tables have been turned on the jeering crowd scenes in *Part the Second*: (#27), "All they that see Him laugh Him to scorn," and (#28), "He trusted in God that He would deliver Him."

FIGURE 46

Example 46: Duet for Alto and Tenor, "O Death, Where Is Thy Sting?," excerpt from beginning

Typically, in a duet, a composer would choose a combination of voices that explored a wide vocal range. Here Handel has used the lower female and the upper male voices separated only by a small margin in their tonal ranges. Except for one note (third space C) the alto range is within the normal vocal range of a tenor. Conversely, except for a

handful of notes (bass clef fourth line F and fourth space G) the tenor range is accessible to an alto. The result is that "O death, where is thy sting?" and "O grave, where is thy victory?" occupy the same limited tonal range.

Handel is setting us up for the chorus that follows (#51), "But thanks be to God who giveth us the victory," where the soprano line will soar above the highest note the alto sings in this duet. Victory over the duet's death and the grave will occupy a different tonal dimension.

On the final page of the duet the music turns to c minor to accompany the consequences of death and sin: "The sting of death is sin, and the strength of sin is the law." The defiant and mocking tone of the first half of the Eb Major duet has been replaced by the c minor dark side and its affect of "languishing, longing, and sighing." The alternative powers—sin and death—will be subdued by the resurrection. The concept is fortified at the conclusion of the duet, where both voices converge on the same note—middle C. Only C. No other notes of the chord that would indicate major or minor.

Ambiguity; what will the outcome be?

Handel has indicated in the musical score to attack immediately the chorus that follows. In two notes the music returns to Eb Major, the bright side. Languishing is banished by an exuberant offering of thanks for the victory over sin, death, and the grave.

#51
Chorus
But thanks be to God, who giveth us the victory through our Lord Jesus Christ.
(1 Cor 15:57)
Affect: "Eb Major"
Love, Devotion, Intimate Conversation with God

FIGURE 47

Example 47: Chorus, "But Thanks Be to God," excerpt on "thanks"

The word "thanks" appears nearly eighty times! The victory accomplished in the death and resurrection of the Lord Jesus Christ has elicited this exuberant outpouring of thanksgiving in the affect of "intimate conversation with God." The offering of thanks leaping off the score is an

effusive gesture, reflecting gratitude for the final victory at the heart of Jennens' *Spiritual Collection*.

<div align="center">

#52
Soprano Aria

If God be for us, who can be against us?
Who shall lay anything to the charge of God's elect?
It is God that justifieth, who is He that condemneth?
(Rom 8:31)

It is Christ that died, yea, rather, that is risen again,
who is at the right hand of God, who makes intercession for us.
(Rom 8:33–34)

Affect: "g minor"
Discontent, Uneasiness, Worry about a Failed Scheme

</div>

Tucked into the middle of thirty choral score pages in major keys is this six-page soprano aria in a minor key. It follows outpourings of joy, victory, and delight for God's defeat of sin and death, many of which were in the significant affect of D Major, and precedes the final three choruses, also in D Major. This g minor soprano interlude merits attention.

"If God be for us, who can be against us?" Taken out of the oratorio's context the text depicts a confidence that is totally contrary to its scriptural intent, given the martyrdom of all but one of the apostles.

To clarify the proper intent of the text, Jennens could have included the passages from Romans immediately following these verses, where Christ, the risen One, intercedes. Verses 36–39 state the inevitability of union with Christ because of the promised resurrection:

> *For Thy sake we are being put to death all day long; we were considered as sheep to be slaughtered. But in all these things we overwhelmingly conquer through Him who loved us. For I am convinced that neither death, nor life, nor angels,*

> *nor principalities, nor things present, nor things*
> *to come, nor powers, nor height, nor depth, nor*
> *any other created thing, shall be able to separate*
> *us from the love of God, which is in Christ Jesus*
> *our Lord.*

Christ, who died, was raised, and is seated on the throne of heaven, prays on our behalf—"If God be for us, who can be against us?" The text expresses a continued hope; in spite of suffering and death, we shall live forever. Why, then, the minor key? Why, specifically, g minor with its affect of "discontent, uneasiness, worry"?

One could look back to the last instance of g minor— one short phrase from the chorus (#46), "For as in Adam all die." But those words were offset by the phrase that followed: "Even so in Christ shall all be made alive."

We need to go back to the soprano aria (#38), "How beautiful are the feet of them that preach the gospel of peace." Jennens placed those words in the context of the spread of the gospel as recounted in the Acts of the Apostles. The message they proclaimed was powerful and transformative, but God's enemies had not yet been defeated, and all but one of the apostles died as martyrs. A price was paid by the willing participants in the eternal drama.

Jennens' choice of this text reminds us that in the midst of the certainty of eternal life the possibility of personal sacrifice remains; Christian martyrdom continues.

The aria "If God be for us, who can be against us?" serves another purpose in the oratorio. We are being set up for the *Grand Finale*, three giant hymns of praise that will ring for eternity around the throne of heaven.

22

SCENE 16: AROUND THE THRONE OF THE LAMB

On the final pages of *Messiah* earth is left behind. Redeemed humanity is seated around the throne of the Lamb who Scripture says was slain from the foundation of the world, yet lives and reigns. Jennens' *Scripture Collection* has cast us as participants in a grand historical drama: *eternity preceding creation, the fall in the garden of Eden, human history*, and finally *eternity at the consummation of the age*. Fourteen books of the Bible, seven from the Old Testament and seven from the New Testament, have illumined the path plumbing both the depths of human degradation and the heights of divine intervention.

Jennens could have used Rev 5:11 as a recitative, "Then I heard the voices of countless angels, thousands upon thousands, around the throne, and they cried aloud . . . ," setting up the final choruses which begin with "Worthy is the Lamb Who was slain" (Rev 5:12). He chose instead to leap directly into the gathering of God's redeemed singing

at the foot of the throne. No more anticipatory recitatives were needed to prepare the way to the future. We are there!

#53
Chorus

Worthy is the Lamb that was slain, and hath redeemed us to
God by his blood,
to receive power, and riches, and wisdom, and strength,
and honor, and glory, and blessing.
(Rev 5:12)
Blessing and honor, glory and power be unto Him that sitteth
upon the throne
and unto the Lamb for ever and ever.
(Rev 5:13)
Amen.
(Rev 5:14)
Affect: "D Major"
Triumph, War Cries, Victory, Hallelujahs, and Rejoicing

In one fortissimo orchestral D the g minor world of uneasiness, worry, and persecution—"If God be for us, who can be against us?"—is left behind in favor of "triumph, war cries, victory, hallelujahs, and rejoicing." One beat later, eternity explodes into existence with the redeemed shouting, "Worthy is the Lamb that was slain." Time is no more.

Time, which has throughout history been linear and degenerative, moving from order to chaos according to the Second Law of Thermodynamics, has ceased to exist. There will be from this point forward only the "eternal now." This moment of singing "Worthy is the Lamb" will be without beginning, middle, or end. Everything that ever was, is, or will be is comprehended in this glorious instant: "Is"—not "was," not "will be." No more waiting. No clocks or watches. No sunrise or sunset. No calendars marking days, months, years, decades, centuries, millennia. Only this moment!

And the sound of "Worthy" is deafening and lump-in-the-throat beautiful.

In many ways the opening chorus of the final trilogy, "Worthy is the Lamb that was slain," parallels the chorus (#46), "Since by man came death." There the emphasis was on Messiah, who overcame the sin of Adam: "by Man came also the resurrection from the dead." Here the emphasis is on the worthiness of the One whose actions provided humanity's redemption: "Worthy is the Lamb that was slain, to receive power."

Both movements share the same "slow-fast-slow-fast" configuration, and the monosyllabic and homophonic declamation of both choruses seem more characteristic of recitative. As was stated at the beginning of this treatise, recitatives and their texts carry the action. These two choruses mark the most dramatic and consequential action of *Messiah*; that is, the promise of transformation from death to life and the fulfillment of that promise.

In one single, profound way the two choruses are dissimilar in that their affects are completely different. The minor dark side keys of (#46), "Since by man came death," have been replaced by the affect of D Major, expressing "triumph, war cries, victory, rejoicing, and hallelujahs." Future hope has become present and eternal reality.

In the twenty-fourth measure, the second chorus begins with cellos, basses, and men's voices proclaiming in unison the first "Blessing." Nothing gets in the way of the melody and its text: no harmony, no extraneous rhythms. As the choral page turns, the entire four-part chorus begins its polyphonic treatment with the orchestra mirroring the voices. Eventually the upper strings break from the singers with an exuberance that appears unable to control itself. A final homophonic cadence slows down the energetic

polyphony and opens into the finale of the three-part choral trilogy, the "Amen."

Messiah ends just as it began: with a fugue, the quintessential musical structure of the Baroque period. In a fugue the *subject* (melody) is stated once by each of the four voices in an opening section called the *exposition*.

Development follows the exposition, where the subject is examined thoroughly through elaboration, expansion, and fragmentation in order to squeeze into awareness every single detail of the melodic idea. It is as if a microscope is gradually turned up to its highest power, revealing every artistic molecule, every aesthetic atom at the heart of the inspiration. Development sections spin their way to the fugue's dramatic conclusion.

There is a world of difference between *Messiah's* beginning and concluding fugues. The opening fugue was in e minor, expressing the "lament, sighs, tears, grief, mournfulness, and restlessness of a world in need." It set the grand drama into motion with questions: What has happened? Why? Is there any remedy? Who will supply it? How will it all end?'

Handel's concluding *Grand Fugue*, though only three measures longer than its opening counterpart, seems immense by comparison, and dramatically different.

Following the exposition of the fugue—after each of the four voices has sung the fugal subject—Handel breaks with fugal tradition and interjects a ten-measure orchestral interlude using just the violins. They seem to interrupt the fugue's momentum, delaying the drama of the development section.

Immediately the full ensemble explodes in a fortissimo "Amen," marking the beginning of the development section, only to be interrupted once again by another violin interlude. Not to be thwarted, a second explosion occurs

and the energy of Handel's magnificent development section continues unabated, rushing headlong to the final Adagio "Amen."

FIGURE 48

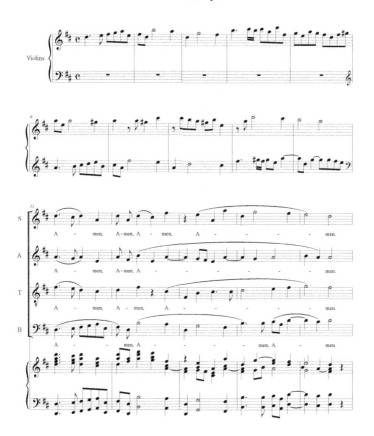

Example 48: Chorus, "Worthy Is the Lamb That Was Slain," excerpt, orchestral interlude in "Amen"

Handel appears to have used those two brief unexpected violin interludes to set up two additional, exuberant

choral explosions. What a brilliant gesture! The "Amen" resounds in every voice in long and numerous melismas, adding gloriously to the overwhelming joy of these concluding pages.

Whatever questions were raised at the outset of *Messiah* have been answered. The dark side and the shadows of the opening Sinfony have been completely eliminated by the bright light of Messiah's resurrection. Fallen creation and fallen humanity have become the recipients of redemption.

To hear the "Amen" is to exult in hope. To sing it is to participate in one of the greatest moments of beauty this side of heaven. There is no greater exclamation point one could possibly add, either to Jennens' *Scripture Collection* and Handel's magnum opus, or to our continuing life of faith: history is past; eternity has begun!

DISCUSSION QUESTIONS

1. Again, check out the descriptions of affects in chapter 1. While examining each movement compare the text with Handel's chosen affect, and then determine if you feel it was the best choice. What affect would you have chosen? Why?

2. Handel set one of the most beautiful arias of the entire work—"How beautiful are the feet of them that preach the gospel of peace"—in g minor, whose affect is "discontent, uneasiness, worry about a failed scheme." He did the same for the aria "If God be for us, who can be against us?" The texts of both reflect the mission aspect of the gospel message: a positive endeavor set in a threatening aspect. Jennens felt Christianity was under threat of the Enlightenment. As you look at your contemporary world, what

parallels do you see? Does the resurrection promise of the Scriptures and Jennens'/Handel's treatment give you courage?

CONCLUSIONS

*Breaking the "Cardinal Rule"
of Composition*

THE CARDINAL RULE OF composition is that a piece must end in the same key as its beginning. Choosing e minor, as Handel did at the outset of Messiah, the composer had a choice. He could end in that same e minor or move to its relative G Major. Handel did neither. The final three choruses are in unrelated D Major.

Why did Handel break the rule? Allow me a speculation. D Major is really the heart and soul of this masterpiece. Fully eleven movements are in that key. "Triumph, war cries, victory, rejoicing, and hallelujahs" constitute an affect of hope, victory, and above all, a new beginning.

D Major's first appearance was eight movements into the work with the text "Behold, a virgin shall conceive and bear a son." It's last appearance permeates the final three choruses. These two "bookending mysteries" at the heart of Jennens' *Scripture Collection*—the *virgin birth* and the *gathering around the throne of Messiah*—form the promise and fulfillment of the great reconciling of heaven.

What about the first seven movements that describe a world alien to God's intent in creation? In my opinion they serve as "prelude" or "prologue" to God's D Major promise.

The "prelude" and "prologue" are over. We wait in D Major hope.

A FINAL WORD

The landscape of *Messiah* is a portrait of our human dilemma. It begins with words of comfort, follows the predictions of a coming Messiah whose intervention will bring a solution to our catastrophic existence, and ends at the throne of heaven. The cosmic vision and promise of Jennens' *Scripture Collection* and Handel's *Messiah* is that a world in need of comfort will become "the kingdom of our Lord, and of his Christ, and he shall reign forever."

GEORGE FRIDERIC HANDEL'S PARTING WORDS

In 1759, the nearly blind Handel conducted a series of ten concerts. After performing *Messiah*, he told some friends that he had one desire:

> *I want to die on Good Friday in the hope of rejoining the good God, my sweet Lord and Savior, on the day of his resurrection.*[2]

On Good Friday, he bade farewell to his friends and died the very next day—Holy Saturday, April 14th, 1759.

2. Jane Glover, *Handel in London* (London: Pegasus, 2018), 385.

About the Author

Gregory S. Athnos
Emeritus Professor of Music, North Park University
Chicago, Illinois

Gregory S. Athnos served as associate professor of music for thirty-two years on the North Park University faculty. In his second year he founded the popular Chamber Singers and toured extensively with them throughout the United States, Canada, Scandinavia, Russia, Estonia, and Italy. In 1975, he was founder and first conductor of the University Chamber Orchestra, continuing in that position until 1982. In 1986, he was appointed Director of Choral Organizations and conductor of the University Choir, leading that organization in concert tours across the United States, Poland, Hungary, Sweden, Russia, and Estonia. Altogether, he organized and led thirty domestic and foreign tours for the ensembles of the music department, conducting over one thousand concerts. Mr. Athnos also appeared as conductor in Minneapolis Orchestra Hall on six occasions, in Chicago's Orchestra Hall (Symphony Center) twenty-five times, and as guest conductor for the Chamber Orchestra of Pushkin, Russia, and the State Symphony of Estonia, conducting their first performances of *Messiah* since the Bolshevik Revolution.

In 2007, Mr. Athnos became conductor of the Majesty Chorale, comprised primarily of Christian Chinese

immigrants. Invited to participate in the 2008 pre-Olympic Festival in China, they sang nine concerts of Sacred Music in Beijing, Tsingdao, and Shanghai. He also served seven years as conductor for the Chamber Choir of North Suburban Church in Deerfield, Illinois.

Mr. Athnos was one of the most respected teachers on the university campus. "Innovative," "enthusiastic," "provocative," and "challenging" were terms often used by his students, who called his lectures "lessons in life." Since 1976 he has taught in the national Elderhostel Program (now Road Scholar) on two campuses, Wisconsin and New Hampshire, where his more than four hundred weeks of lectures on a variety of topics related to the arts have garnered rave reviews from his participants. One adult learner wrote, "He is the Beethoven of lecturers." In 2005, he was honored by Elderhostel International as one of its most highly praised instructors.

Mr. Athnos received his degrees from Northwestern College in Minneapolis, Minnesota, and the University of Michigan, where he was elected to the National Music Honors Society. He has studied Norwegian folk music and its influence on Edvard Grieg at the University of Oslo. He has published twenty articles and poetry in *Pro Musica* (the music journal of the former Yugoslavia), the *Mennonite Journal*, the *North Parker*, the *Covenant Companion*, and *Christianity and the Arts*. Mr. Athnos was recipient of the 1990 Sears Foundation Award for Teaching Excellence and Campus Leadership, and the 1992 Honorary Alumnus Award, conferred by the Alumni Association of North Park University, an honor granted only rarely in the school's one hundred–plus-year history.

He has traveled throughout North America, Europe, and Japan as conductor, guest clinician, and as lecturer in

music and theology, the latter emphasizing the theological significance of the art of the Roman catacombs. His research culminated in two books, published in 2011: *The Easter Jesus and the Good Friday Church: Reclaiming the Centrality of the Resurrection* (recipient of the 2014 Christian Writers Award First Place in Theology) and *The Art of the Roman Catacombs: Themes of Deliverance in the Age of Persecution* (recipient of the Reader Views Literary Awards First Place in History/Science). A third book, his autobiography, was published in 2016: *Eat in Harmony: A Feast of Life, the Arts, and Faith.*

Mr. Athnos retired from university teaching in 1998 and has kept a busy schedule of lectures and seminars for arts organizations, Elderhostel/Road Scholar, museums, colleges, conference centers, retirement communities, and churches.

Printed in Great Britain
by Amazon